IMAGES
of America

GILBERT

Gilbert Historical Museum
10 S. Gilbert Rd., PO Box 1484
Gilbert, AZ 85299
480-926-1577
www.gilbertmuseum.org
www.facebook.com/gilbertmuseum

IMAGES
of America

GILBERT

Please enjoy ?

Dale Hallock, Kayla Kolar, and Ann Norbut,
on behalf of the Gilbert Historical Society

Dale C. Hallock

Ann M Norbut

Kayla Kolar

ARCADIA
PUBLISHING

Published by Arcadia Publishing
Charleston, South Carolina

Printed in the United States of America

Library of Congress Control Number: 2014946272

For all general information, please contact Arcadia Publishing:
Telephone 843-853-2070
Fax 843-853-0044
E-mail sales@arcadiapublishing.com
For customer service and orders:
Toll-Free 1-888-313-2665

Visit us on the Internet at www.arcadiapublishing.com

This book is dedicated to the people of Gilbert—the pioneers who came in the late 1800s and all who have called Gilbert home since then.

CONTENTS

ACKNOWLEDGMENTS

The Gilbert Historical Society owns and operates the Gilbert Historical Museum and has been a repository for the history of Gilbert for many years. Researching archives of old newspapers such as the *Gilbert Sun,* the *Gilbert Enterprise,* the *Arizona Republican* (later the *Arizona Republic*), the *Mesa Tribune,* and other Arizona newspapers has provided many answers to where Gilbert came from and why it is still here, as well as why it is flourishing even today.

We thank both the people of Gilbert who have donated photographs and archival material to the historical society through the years and the Town of Gilbert for access to its records. Ann Pace, who began chronicling family histories in Gilbert in the 1980s; former Gilbert librarian Pat Castenada, who conducted many oral history interviews during and after her tenure; Danette Turner, who conducted oral history interviews and wrote a history of the Gilbert Police Department, *From Star to Shield;* Dr. Maria Hesse, who wrote the history of Chandler-Gilbert Community College for her dissertation; former town manager Kent Cooper, who wrote a history of what happened during his 18 years at the helm; and others who continue the work of gathering oral histories are invaluable to an undertaking such as this book.

Others who have provided critical pieces of information and photographs include Melanie Dykstra, Jessica Fierro, Kyle Mieras, Nicole Lance, Dan Henderson, Jennifer Graves, Vicky Songer, John Hudson, Adam Walterson, Cathy Templeton, Jo Albright, Linda Abbott, George Pettit, Greg Tilque, Kathy Tilque, Cindy Barnes Pharr, Cathy Chlarson, Julie Graham, Susan Karesky, Julie Collins, Howard Morrison, the Chandler Museum, the East Valley Museum Coalition, Gina DeGideo, and Mary Melcher—we thank you!

And to those who have fact-checked, scanned photographs, and proofread over and over again—Lisa Anderson, Paul Norbut, Cathy Baldwin, Jim Waggoner, Caitlyn West, and Dotty West—you are the best! We appreciate the support given to us by the Gilbert Historical Society board of directors, all the volunteers of the museum, and especially our families for their patience and understanding.

Unless otherwise noted, all images appear courtesy of the Gilbert Historical Society and Museum.

INTRODUCTION

Some would say that Gilbert is just like the other suburbs of Phoenix, and in some ways it is. All of these communities began as agricultural areas. Most of these people traveled great distances to find hope, prosperity, and good weather in a new land. In 1890, territorial governor Conrad Meyer Zulick was the first to homestead in the extended area, but it was a woman, Bee Barstow Halsey, who filed the first homestead patent in the small one-square-mile area that was known as Gilbert. Halsey, however, never actually lived in the area, so it was the Anderson family who were the first to homestead (in 1891) and actually live in Gilbert. With a population of over 500 in 1920 (the minimum number needed), Gilbert became an incorporated town.

Those early days in Gilbert were similar to those of many other Arizona cities and towns. But what makes Gilbert unique is the incredible growth that began in the late 1970s and will continue until the land is fully developed, which is expected to be around 2040 (anticipated population of 330,000). Two things spurred this growth—the extension of the Superstition Freeway from Phoenix to Gilbert and the strip annexation of 53 square miles in 1975 that gave Gilbert the land to grow. Gilbert doubled its population every five years from 1980 to 2010 and continues to be one of the fastest-growing towns in the country.

Many wonder why Gilbert is a town and not a city. The main difference between the two is that a city may adopt a charter to have more flexibility in making decisions locally while a town operates under the general laws of the state. Arizona has constitutional charter authority, and local determination is incorporated in the state constitution, which is less likely to be altered. Through the years, Gilbert's leaders have continued to support the structure of the town model.

While Gilbert stayed the same small agricultural community from the late 1800s to the mid-1970s, things began to change in the post–World War II decades. With the advent of new technology and machinery, life became a little easier for these early homesteaders and their descendants. New infrastructure came to the town, such as modern sewer systems and paved roads.

In the 1970s, the town took on a more Western look, as many businesses redid the facades of their buildings. Street names were changed to honor some of the early pioneer families. First Street became Page Avenue, Second Street became Vaughn Avenue, and Central Avenue became Cullumber Avenue. Until that time, Gilbert Road had been known as Main Street in the downtown business district, which is now called the Heritage District. From a postal address standpoint, the center of town, the zero/zero point, was marked at what is now Cullumber Avenue and Gilbert Road but was moved to Elliot and Gilbert Roads in the mid-1970s.

Businesses in the Heritage District frequently changed owners and names in those first few decades. But the growth that has occurred since 1980 has been extraordinary and challenging. A governmental service organization had to be created to support this incredible growth. The mayor, council, and Town of Gilbert employee leadership were committed to excellence and recognizing that government had an obligation to be a solution center and not just a regulatory agency. There was an emphasis on partnerships and outside-the-box thinking to provide and

finance the needs of the community. Gilbert's first wastewater treatment plant was a private partnership between a corporation and several developers. In 1985, Gilbert purchased its own equipment for dispatching police instead of relying on Maricopa County. Chief Fred Dees began a community-building police approach that was evident when Gilbert started to experience gang activity. He worked with Gilbert Public Schools and the Boys and Girls Club of the East Valley to start a branch club in Gilbert Elementary School. By identifying a partner who already had the resources to address the needs of at-risk youth, it was a unique solution to this problem. A third example of expanded town services through partnerships was when Gilbert stopped operating its own library and partnered with Maricopa County to build the Southeast Regional Library. Through the years, Gilbert's approach has been to partner with others to be efficient and effective in managing the growth.

Some wonder what Gilbert's relationship is to Higley. Higley was an unincorporated community in Maricopa County named after Stephen Weaver Higley, who was one of the first landowners in the area in 1905. Higley also had its own elementary school, established in 1909. Higley had a post office and a zip code, but in 2007, the US Postal Service abolished the zip code for physical addresses but kept it for post office boxes. Because most of the Higley area has officially been incorporated into Gilbert, Mesa, or Queen Creek, all that is left of Higley is the school district.

Newcomers to Gilbert are often puzzled because the municipal boundaries do not align with school-district boundaries. Often, the municipalities continued to grow long after the school-district boundaries had been established. Residents of Gilbert can be in the Gilbert, Higley, or Chandler School District. Residents of Mesa and Chandler can also be in the Gilbert School District. There are also many charter and private schools in Gilbert as well as a strong home-school contingent.

Since 2010, Gilbert has been recognized for excellence in many areas, including being named the 22nd-Best Place to Live in the United States by *Money* magazine, the 2nd-Safest City in the United States by *Law Street Media*, and the Best City for Working Parents by *WalletHub*. In 2011, Gilbert was the recipient of the Freedom Award, the highest recognition given by the US Secretary of Defense to organizations for the support of their employees who serve in the National Guard and Reserve.

As Gilbert has grown, it has become known as a great place to raise a family. In 2014, the median age of all residents was 31.5. Almost 37 percent of the population is under the age of 19, and another 37 percent is between 20 and 44. Gilbert is a community with great family entertainment, including an extensive trail system, a soccer complex, nationally recognized parks, a history museum, and annual celebrations like the Gilbert Days Parade and Rodeo. People say Gilbert has a "small-town feel" and is a "clean, safe, and vibrant" community. But what has made the town all those things? It is the people—from those who came in the late 1800s to those who have continued to come to this day who treasure those values and call Gilbert home.

One

GILBERT BEGINS

The first homesteaders came to the Gilbert area in 1886 and began filing claims as early as 1890. Arizona's seventh territorial governor, Conrad Meyer Zulick, was appointed by President Cleveland and served the Arizona Territory from 1885 to 1889. Governor Zulick's homestead claim was recorded on December 20, 1890, near what is now Val Vista and Warner Roads, and it was the first homestead filed in Gilbert, although outside of what is typically considered early Gilbert.

In November 1891, Bee Barstow Halsey purchased a section to the west of Zulick's parcel bounded by Elliot, Gilbert, Lindsay, and Warner Roads. Halsey was the first woman to homestead in the Gilbert area and the first person in what was the original Gilbert. In December 1891, John Logie Anderson's family homesteaded 160 acres on Main Street (Gilbert Road) half a mile north of Guadalupe Road that later grew to 400 acres. Anderson was the first to homestead and stay in the area, and his descendants still reside in Gilbert over 100 years later.

Many other homesteaders arrived, cleared, and leveled the land, built farms and ditches, and grew crops, the most successful of which was alfalfa. These mostly Midwesterners could grow three crops a year in their home states, but they now found they could grow up to nine cuttings a year. The canals brought the water needed for farmers to survive. The Consolidated Canal was the first, followed in 1911 by the Eastern Canal. In the 1920s, the Roosevelt Canal extended farming east past Power Road.

On June 10, 1898, Bobby Gilbert homesteaded a 160-acre parcel between today's Western Canal and Elliot Road, which extended west half a mile from Main Street (Gilbert Road). In 1902, Frank Murphy purchased a right-of-way from Gilbert for a railroad he wanted to build to the mining towns to the east. The new railroad spur line (dual track for loading and unloading) was called the Gilbert Spur. The town grew up around it, and that is how Gilbert was named.

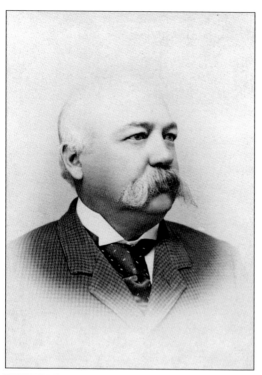

Governor Zulick was an attorney by trade but was living in Tombstone in 1884, overseeing a mining operation in Mexico. During his term, he was responsible for moving the territorial capital from Prescott to Phoenix. He homesteaded a section of land at the northwest corner of Val Vista and Warner Roads where he planted palm trees. The Gilbert Historical Society relocated the trees to the corner and placed a monument to honor Zulick at that site in 1998. (Left, courtesy of Arizona State Library, Archives, and Public Records, History and Archives Division, Phoenix, #96-1381.)

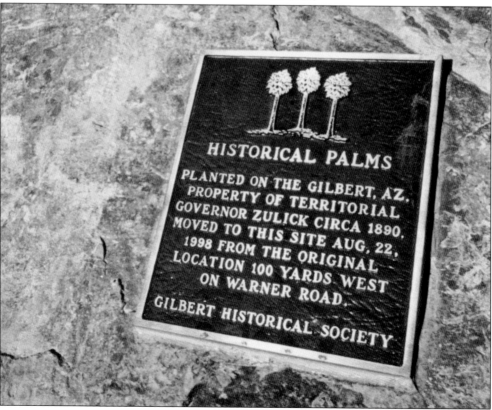

HISTORICAL PALMS

PLANTED ON THE GILBERT, AZ,
PROPERTY OF TERRITORIAL
GOVERNOR ZULICK CIRCA 1890,
MOVED TO THIS SITE AUG, 22,
1998 FROM THE ORIGINAL
LOCATION 100 YARDS WEST
ON WARNER ROAD,
GILBERT HISTORICAL SOCIETY

William Michael Gilbert was born in Missouri and was a supporter of the South during the Civil War. He chose to be called Bobby in honor of his hero, Confederate general Robert "Bobby" E. Lee. Ironically, Bobby never actually lived on the Gilbert property he sold to the railroad. He died in 1945 and is buried in the City of Mesa Cemetery.

LOCATIONS OF THE EARLY HOMESTEADS
IN THE SIX MILE RECTANGLE SURROUNDING THE ORIGINAL
DOWNTOWN GILBERT

Township 1 South Range 5 East — Township 1 South Range 6 East

Baseline Road

Homestead Entry Patent by James A. Barkley 12 Dec. 1898	Homestead Entry Patent by Dennis K. Barkley 13 June 1901	Homestead Entry Patent by John A. Cuber 8 Feb. 1892	Homestead Entry Patent by Thomas Anderson 6 Nov. 1895
Homestead Entry Patent by John A. Barkley 12 Dec. 1898	Homestead Entry Patent by Jennie M. Barkley 30 March 1896	Homestead Entry 1 Dec. 1891 Patent by George Anderson	Homestead Entry Patent by Estate of George Anderson 4 Feb. 1904
		Homestead Entry 7 Jan. 1898 Patent by John L. Anderson	

Guadalupe Rd.

Timber Culture Patent by John A. Barkley 17 June 1898	Homestead Entry Patent by James Pine 11 July 1896	Homestead Entry Patent by William B. Allison 1 April 1899	Homestead Entry Patent by George W. Allison 1 April 1899
Homestead Entry Patent by John A. Plattner 6 June 1896	Homestead Entry Patent by William M. Gilbert 10 June 1898	Homestead Entry Patent by Fred C. Weekes 10 June 1898	Cash Entry Patent by Rosetta P. Jones 14 Feb. 1893

Elliot Road

Cash Entry Patent by Ida F. Lewis 3 Feb. 1898	Cash Entry Patent by Lillian N. Gibbs 2 Aug. 1895	Cash Entry Patent for entire section by Bee Barstow Halsey 16 Nov. 1891	
13		18	

Warner Road

Cooper Road — *Gilbert Road* — *Lindsay Road* — *Phoenix & Eastern RR*

This homestead entry map shows each parcel with a number listing the first 20 parcels that were filed between 1891 and 1904 in the six sections surrounding the future town of Gilbert. Each of the early families is listed. During that period, the president of the United States personally signed every homestead conveyance issued.

11

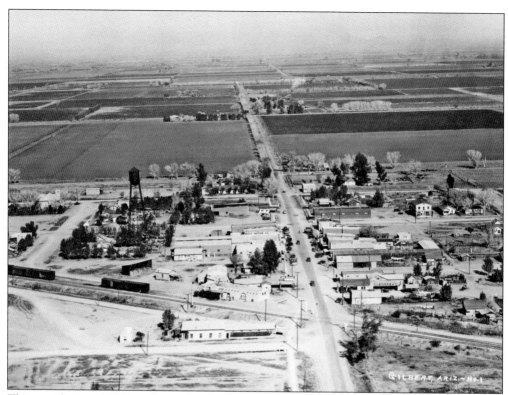

This aerial view of Gilbert shows the depot on the left side of Main Street (Gilbert Road) and north of the railroad tracks. Downtown Gilbert was a two-block area with merchants on both sides of Main Street, which has been known as Gilbert Road since the 1970s. This photograph shows the half mile of fields between the town and the first home site to the north.

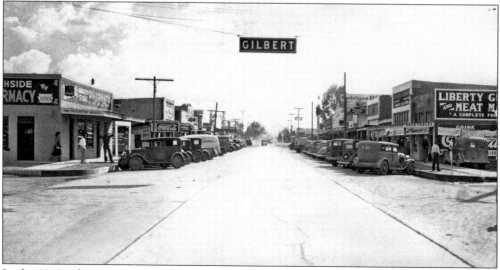

In the 1940s, the town residents hung a sign over the intersection of First Street (Page Avenue) and Main Street (Gilbert Road). The Gilbert sign, the water tower, and the Gilbert Depot were the three distinguishing points that set Gilbert apart from their nearby neighbors. The water tower could be seen from Baseline Road.

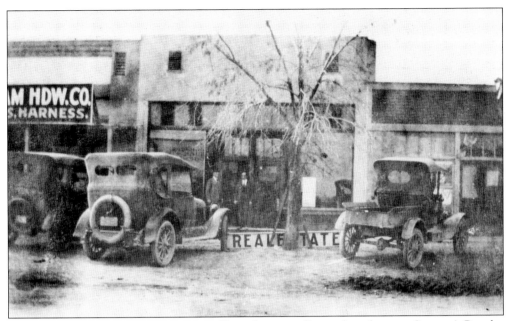

Originally, this building was C.H. Russell's real estate office; it later became Serrano's Popular Store. It was on the west side of Main Street north of the Blakely Building. Louis Serrano ran the store and then turned the business over to his brother Albert. Albert's son Albert Jr. managed the store for over 25 years. Albert Jr. and his wife, Rosemarie, raised their children in a house on the corner of Linda Lane and Main Street.

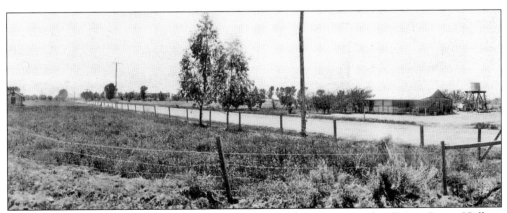

The Harmon family came to Gilbert in 1913 and farmed on the west side of Main Street (Gilbert Road) and south of the railroad tracks and the Barber Building. The home had its own well with a tank above the well to collect the water. Today, the Gilbert Chamber of Commerce is across the street from the old Harmon farm site.

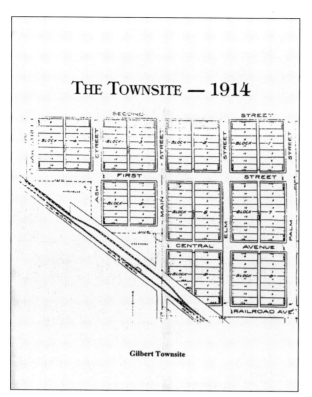

The Townsite — 1914

Gilbert Townsite

The first subdivision in Gilbert, recorded in 1914, was called the Gilbert Townsite and was located on both the east and west sides of Main Street (Gilbert Road) on land owned by Bobby Gilbert and Fred Weeks. The subdivision was filed by E.S. Welch, A. W. Ayers (Gilbert's first store owner), and Cora Burk (the widow of Amos Burk). They became Gilbert's first subdividers.

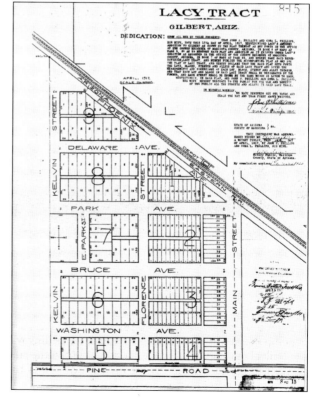

In 1917, the second subdivision was developed by John and Cora Phillips and called Lacy Tract. The lots were on the west side of Main Street (Gilbert Road), south of the railroad, and included the first Gilbert Park, where the first swimming pool was built by the Jaycees in 1947. The Blakely Library was on the south end, and the senior center is currently on the north end, where the pool used to be.

The Consolidated Canal was built at the beginning of the 1900s and came within a mile of downtown Gilbert. It was the lifeblood for farmers needing water for their land. Cottonwood trees lined the East Valley canals and made shady places to enjoy a picnic. The public had access to the canal banks until the 1960s.

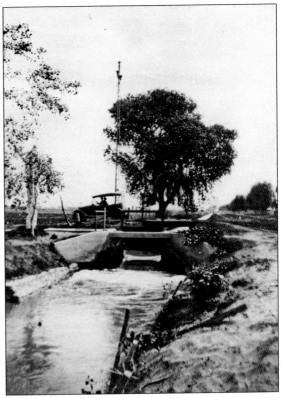

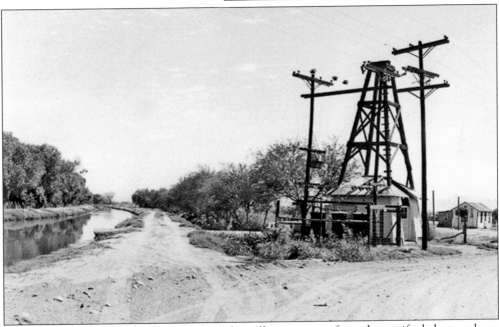

A pump house was an essential ingredient for pulling water up from the aquifer below, and one was built about every mile along the canal. When the pump was running, it gave a constant flow of water for the farmers to irrigate their fields. One of the pumps was called the "hot pump," as it brought hot water up from its source.

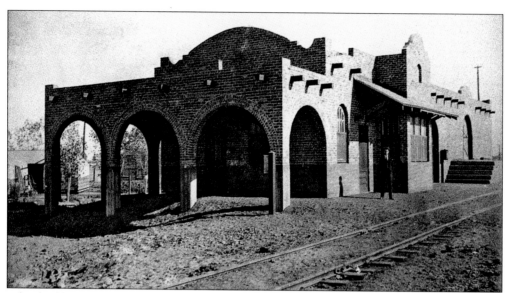

After building the railroad through Gilbert, the Phoenix & Eastern Railroad built the Gilbert Depot in 1905. Except for a few farmhouses, the only thing surrounding the depot was alfalfa growing in every direction. Made of red brick and later stuccoed, it was constructed in the Mission style of the Southwest and put Gilbert on the territorial map of Arizona. The Gilbert Depot was torn down in 1969.

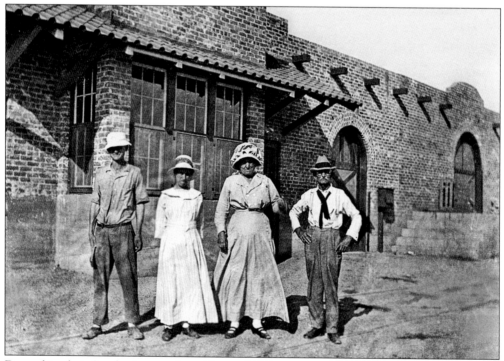

Dressed in their Sunday best, early residents of Gilbert pose in front of the new Gilbert Depot in 1906 as they wait for the train to take them to either Phoenix or Kelvin, the mining district to the east. In addition to travel by horse and buggy and on foot, the train was a primary mode of transportation for many people.

Two

EARLY HOMESTEADERS

The early settlers began coming to the Gilbert area in the 1890s to establish their homes and farms. T J. Fincher and his young son Bruce arrived in 1908. They shipped their entire home and farm belongings in a boxcar to a siding next to the Gilbert Depot. Fincher is famous for saying, as he looked around the depot out toward the surrounding area, "I could see nothing but alfalfa growing in every direction." There were no businesses other than the depot at that time in Gilbert. Some people living in the area wanted the town to be called Pine after one of the earliest families, but there was already a Pine, Arizona.

Settlers began establishing businesses in Gilbert, and by 1914, the first subdivision had been developed. Gilbert's townsite made it possible for people who were not able to farm or homestead a large parcel of land to own a lot with a small home. In 1917, Lacy Tract was developed and named after the family of Phillip and Mary Lacy, who arrived in 1911.

The pioneers developed local customs and social activities, usually around their church and community. Picnics along the canals, hayrack rides, and corn-roasting provided entertainment and a respite from their hard labor. Along the third canal (the Roosevelt Canal), one of the water pumps hit a hot-water pool below that created a place for people to relax from their responsibilities.

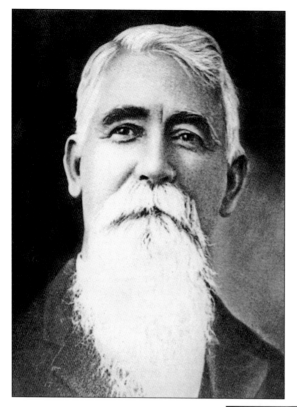

James Pine (left) arrived in the Gilbert area around 1896 and homesteaded 160 acres at the southwest corner of Guadalupe and Gilbert Roads. His son Charles developed and cultivated the land and later served on the Gilbert School Board. Alfred Pine (below) was the son of Charles and the grandson of James. Alfred graduated from Gilbert High School, went to college, and then returned home to farm the family homestead. Alfred also served on the Gilbert School Board as his father had done before him. Alfred married Marian Bond, whose father was also a homesteader in Gilbert. Marian and Alfred were major contributors in the creation of the Mesa Country Club.

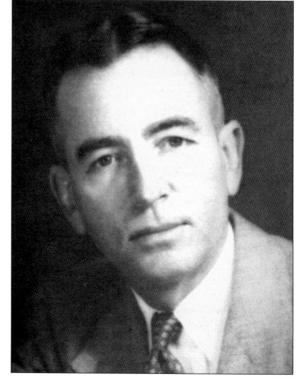

Charles N. Brass homesteaded on the northwest corner of Gilbert and Ray Roads. His daughter Nellie married Lowell Stiles, and they had a daughter named Ruth, who married Hugh Geiszl. Ruth and Hugh raised their family east of Gilbert Road between Elliot and Warner Roads. Ruth was a preservation activist in the community who, in 1998, moved and restored four 1920s-era homes and turned them into businesses to create the Farmhouse Village on their homestead.

This aerial photograph of Gilbert with a view looking northwest was taken from the southeast. On the left side of the photograph are, from bottom to top, the Gilbert Depot, the Capital Fuel, Feed and Seed Company, the Nowell home, the Page Store, and the Blakely Garage. Across from the depot is the back of White's Blacksmith Shop, and to the right is Clement's Garage.

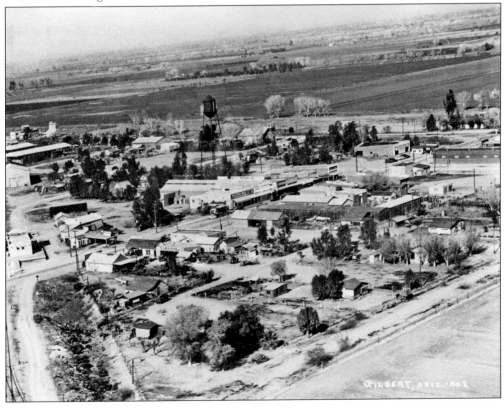

John L. Anderson was born in Canada on August 9, 1853, and was of Scottish descent. He and his wife, Elizabeth Jarrott, migrated to North Dakota, where their children were born. They came to Gilbert in 1886 and were the first to file a homestead patent and actually develop the land. Six of their children attended the Highland School, the first school built in the Gilbert area, in 1900.

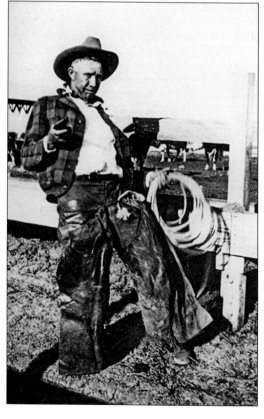

Bill Anderson, son of John L. Anderson, was a cowboy and a farmer. He was a board member of the Bank of Gilbert in 1917 and later was in charge of ranch loans for Valley National Bank. In the 1930s, during the Great Depression, he purchased land for 32¢ an acre east of Gilbert in Mesa, where the General Motors proving ground used to be and where the Eastmark community is now.

Ward Burk and his future wife, Mildred Lacy, met at a picnic in 1913. They later married and went back to Ward's farm in Iowa, where they farmed for four years. In 1918, they moved to Gilbert and worked the Lacy farm southeast of town. Ward served as a constable in Gilbert from 1923 to 1926. He used this automobile to apprehend people who were making whiskey without a license; bootlegging was a common offense during the 1920s and 1930s. Burk also served twice as mayor of Gilbert, first from 1937 to 1939 and again from 1943 to 1945. Burk is shown below with his daughters Harriet (Gibson), Hazel (Miller), and Norma (Rose).

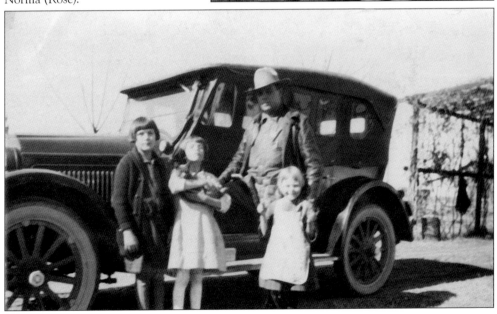

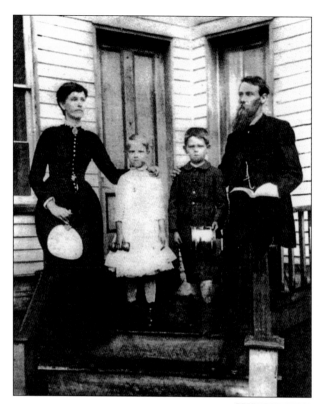

William and Elizabeth Barkley brought their family to the Gilbert area in 1886 and began homesteading land between Baseline and Guadalupe Roads in 1896. Together, the Barkley family members farmed 800 acres. This family donated land for the first two schools in Gilbert—one built in 1900 and another in 1909; each was known as the Highland School.

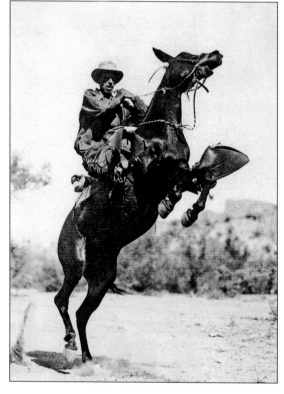

William Augustus Barkley, later known as Tex "Gus" Barkley, was the son of William and Elizabeth Barkley. He loved being a cowboy and purchased the Quarter Circle U Ranch, which he ran for his entire adult life. His son Bill continued running the ranch after Tex died. Tex was famous for his sense of humor and telling stories about the Superstition Mountains, where the ranch was located.

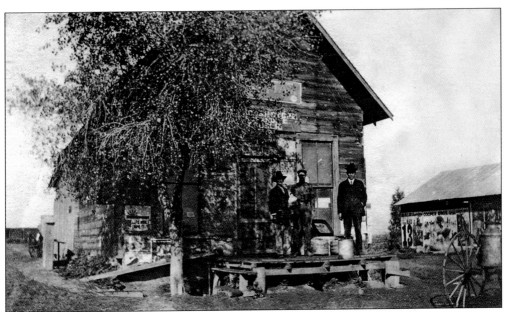

Pilcher Drugstore, located on the west side of Main Street (Gilbert Road) between First Street (Page Avenue) and Central Avenue (Cullumber Avenue), was the first pharmacy in Gilbert. It was later purchased by Hap Nowell, who moved it to the east side of Main Street. It was renamed the Gilbert Rexall drugstore and eventually sold to Tom Cady, who operated it for over 30 years.

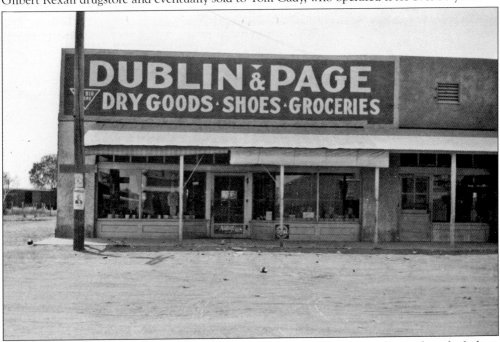

The first store in Gilbert was built in 1910 by A.W. Ayers and stood on the south end of where Norwood Furniture is today. Ayers later took a partner, David Butler. A Mr. Dublin then bought out Ayers. Dublin and Walter M. Page, who eventually bought out Butler, had the Dublin and Page Market, and later Page became the sole owner. Page also served as mayor of Gilbert from 1927 to 1937.

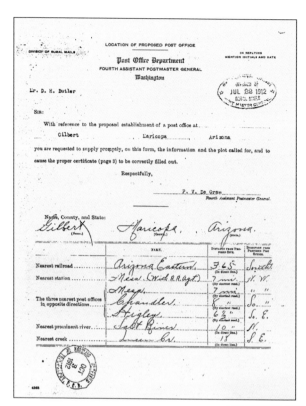

Gilbert was awarded a post office in 1912, and David Butler was the first postmaster. In those days, a post office would often be established in a grocery store or a business. The Ayers and Butler Store was awarded the honor, and Gilbert citizens began receiving mail in their own town. Ethel Lacy and Winnie Johnson were two longtime postmistresses.

Everett and Nelly Wilbur farmed on land given to them by Everett's father at the southwest corner of Gilbert and Elliot Roads. They donated a portion of their property for the Gilbert Public School District's first elementary school built in 1913 and the first Methodist church, south of the school, and developed Wilbur's Home Subdivision. Their children were Robert, Alice, Walter, George, Kathryn, Ethel May, and Joseph.

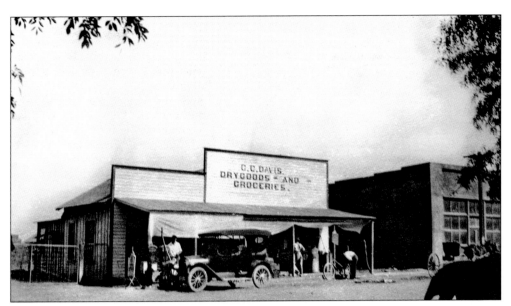

Clive Davis opened the C.C. Davis Market on the east side of Main Street (Gilbert Road) between Central Avenue (Cullumber Avenue) and First Street (Page Avenue). Davis's cousin opened a liquor store and bar at the corner of Gilbert Road and Williams Field Roads called Norton's Corner, which was a very popular watering hole for over 50 years.

Hubert Sawyer homesteaded in Gilbert in 1908. His wife and son, John, followed in 1909. Soon after, a daughter, Elizabeth, was born. In 1909, Hubert helped build the second school in Gilbert, where he later taught. He served on the Gilbert School Board when it was created in 1913. John also served on the school board, and Elizabeth was treasurer of the Gilbert Historical Society for 28 years.

In 1880, Orson Cooper (left) came to Mesa with his parents. He married his wife, Sybil, in 1900, and in 1909, they made their home on the southwest corner of Baseline and Cooper Roads. Their dairy was near the first Highland School. Their son Morris (below) served as mayor of Gilbert from 1959 to 1967, and another son, Jim, was a state representative for many years. In 1921, Morris married Ruth Burk, the daughter of Amos and Cora Burk. They had two daughters, Cleora and Dawn. While mayor, Morris named Burk Street after his wife's family. After Ruth died in 1964, Morris married Gertrude Brookins Mortensen, a widow.

Delbert Mortensen came to Gilbert in 1910 and lived at the northwest corner of Guadalupe and Cooper Roads. He married Gertrude Brookins in 1918, right after she graduated with the first class of Gilbert High School. They had one daughter, Mary Lois. Delbert and Gertrude moved to the Brookins' old homestead property (north of Guadalupe Road and east of Greenfield Road) in 1942. Delbert died in 1959, and Gertrude continued to live on the property with her mother until she later married Morris Cooper. Gertrude (right) was instrumental in the formation of the Gilbert Historical Museum.

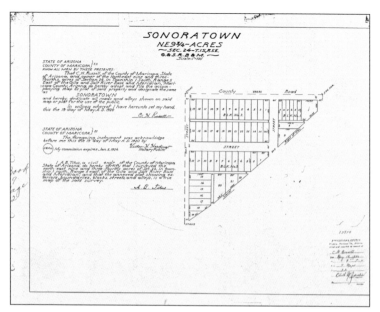

In 1918–1919, C.H. Russell, a local land developer, decided to provide reasonably priced lots for the many Mexicans moving to Gilbert. He developed a triangular parcel of land at the southwest corner of Warner and Gilbert Roads and called it Sonoratown. The lots were sold exclusively to these new immigrants. Many of the original descendants still reside in these homes.

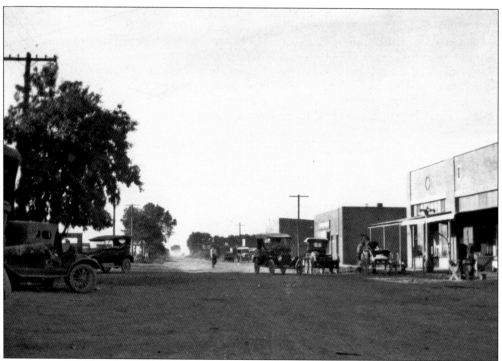

This view looking north shows an unpaved Main Street (Gilbert Road) around 1918–1920. On the far right is the C.C. Davis Store. To the north are the Pilcher Drugstore, the Bank of Gilbert, and then Timmons Garage, which came before the Gilbert Garage. In June 1920, the newly incorporated town made its first major improvement by paving Main Street from a little north of Timmons Garage south to Central Avenue (Cullumber Avenue).

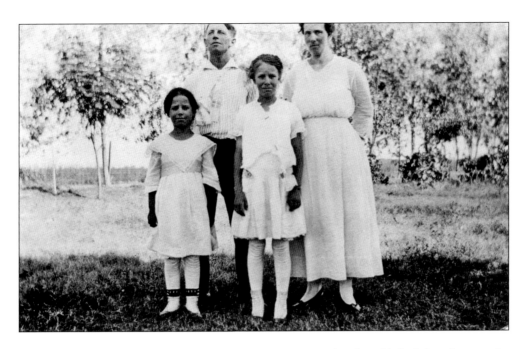

Joseph and Luvena Norton came to Gilbert from Iowa in 1905 and established their farm on the west side of Cooper Road half a mile south of Baseline Road. They had three children—Evelyn, Vera, and Vernon. Joe raised various crops and hogs, operated a small dairy, and also worked at the Gilbert Cotton Ginning Company. In 1930, he started a chicken hatchery and built a second house on the north side of West Park Avenue. Luvena provided room and board for some of the Gilbert teachers. Vera graduated from Gilbert High School in 1928, received her teacher's certificate from Whittier College in Whittier, California, and returned to Gilbert to teach for several years. She then married and returned to California. Above are, from left to right (first row) Vera and Evelyn; (second row) Joe and Vena. Below is the Norton farm in 1912.

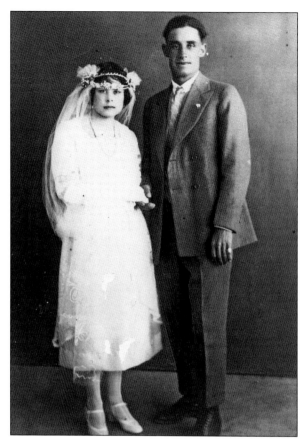

Seen in the photograph at left, Fernando Ruiz married Virginia Contreras on February 14, 1926. They lived in a two-bedroom adobe home built by Fernando on the northeast corner of Ash Street and First Street (Page Avenue), where the Hale Theater is today. They had 10 children—Eva (died at one week of age), Margaret, Manuel "Raul," Dalia "Dolly," Enedina "Annie," Fernando Jr. "Junior," Asusena "Susie," Celia "Sally," Sara, and Conception "Connie." Fernando delivered hay, picked cotton, and herded sheep, and Virginia was a seamstress. Many of their descendants still live in the East Valley. Below are, from left to right, Junior Ruiz, Sara Ruiz (Quinn), Irene Ramirez, and Andrew Lopez in front of Fernando's hay delivery truck.

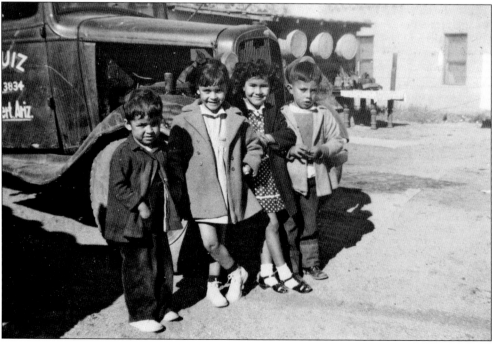

Three

TOWN LIFE

The town of Gilbert grew around the Gilbert Depot. The first business built after the depot was the Ayers Grocery Store in 1910. The Gilbert Creamery and Hauck's Blacksmith Shop were next in 1912. Blacksmith shops became very popular in the Gilbert area, as farmers needed professionally made farm equipment and regular equipment repairs.

Over the last 100 years, many of Gilbert's early businesses went through several iterations before becoming what is located there today. For instance, the Ayers Grocery Store became Ayers and Butler, Butler and Dublin, Dublin and Page, Page, and Valenzuela's Market. That same store today is the south wing of Norwood Furniture.

Other stores soon followed—Pilcher Drugstore in 1916, C.C. Davis Store in 1918; later that same year, C.H. Russell erected a brick building for his real estate company. He sold the building to a clothing store company, which was then purchased by Louis and Albert Serrano and became the Popular Store. This building today is also a part of Norwood Furniture. Bob Merrell, the third mayor of Gilbert, established the first gas station in 1919 on the southwest corner of Main and Second Streets (Gilbert Road and Vaughn Avenue). New businesses flourished from 1910 through the 1930s.

It was a tradition in early Gilbert for the townspeople and those living on nearby farms to do their shopping on Saturday afternoons. After shopping, they would go to the open-air dance floor on the east side of Main Street between the drugstore (which was the original Bank of Gilbert building) and a café. Those who could play a musical instrument would entertain the shoppers on the dance floor. Couples paid 10¢ a dance to waltz or do the two-step. Those Saturday-night dances became the social event of the week in early Gilbert.

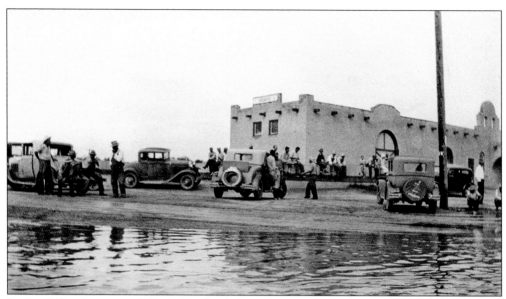

In the 1930s, downtown Gilbert was flooded several times when the Queen Creek overflowed its banks, sending water westward down the railroad tracks. This is a photograph of the depot in the flood of 1938.

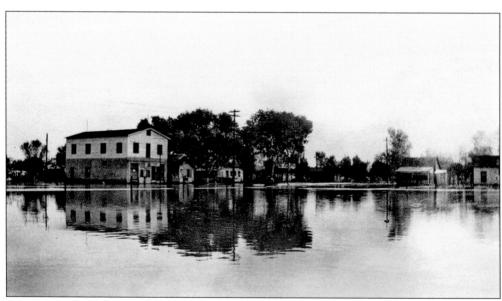

The Woman's Club of Gilbert was organized in the 1920s and served as a center for social communication for the town. This building served as a meeting place and a polling place, and the women's group even raised funds for new town amenities. The two-story Woman's Club building is now a one-story church that sits east of the Tone Building at Page Avenue and Gilbert Road.

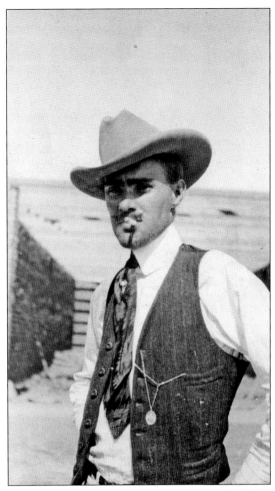

Abe Cosby was not only a real estate broker in Gilbert; he also became the judge for the town. The lawbreakers who were prosecuted were usually accused of intoxication and distilling liquor for sale. Many moonshiners refused to pay the federal tax on their "white lightning." Cosby was a very dapper dresser and liked to be photographed in front of his real estate office in downtown Gilbert. He was one of the early movers and shakers of business and civic life. His office, shown here in 1917, was on the southwest corner of Main and First Streets (Gilbert Road and Page Avenue), next door to where Liberty Market was built in the 1930s.

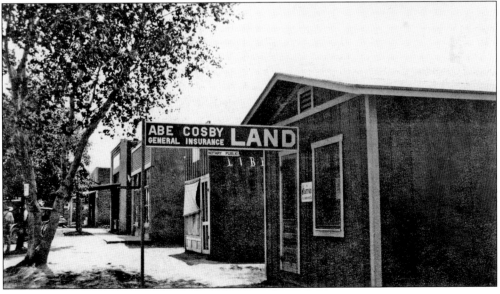

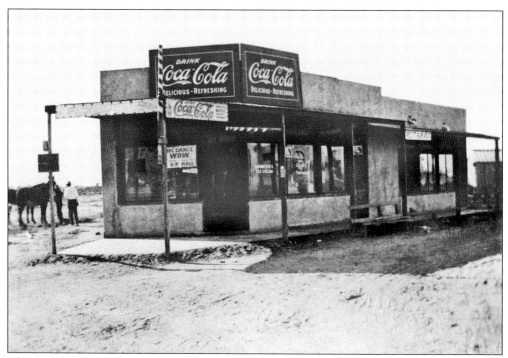

The Barber Building was the first business constructed south of the railroad on Main Street (Gilbert Road). The Barbers were truly barbers by trade and also had a small convenience store. On Saturday evenings, the Barbers provided music for dancing and sold soft drinks and beer. Later, this building housed the *Gilbert Enterprise*, a weekly newspaper begun in 1929. The first owners of the newspaper, the McCormicks, lived in an apartment behind the business.

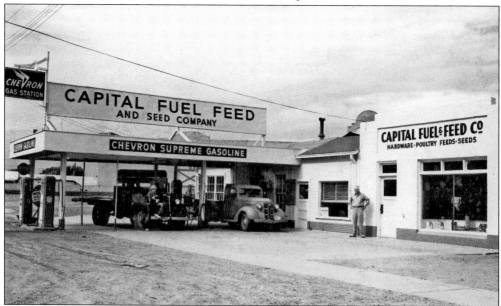

The Capital Fuel, Feed, and Seed Company sold grain, hay, and baby chicks and had a service station and garage. George Aepli was the owner of the company and very active in Gilbert's development even though he lived in Tempe. Originally, Aepli was a hay broker.

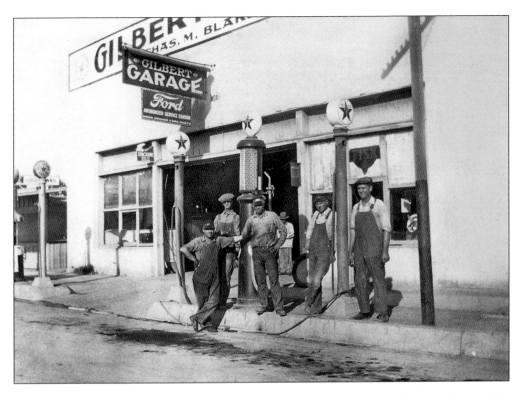

Charles M. Blakely moved to Gilbert in 1918, became partners with Albert Tone, and opened the Gilbert Garage. This building was torn down in 1928, and a new building called the Tone Building was erected at the northeast corner of First and Main Streets (Page Avenue and Gilbert Road). In 1929, Tone leased his building to the Pay 'n Takit chain of modern grocery stores. The Great Depression decimated the new grocery business, and, from that time until today, many different businesses have resided in the Tone Building. Since 1998, it has been home to Joe's Real BBQ.

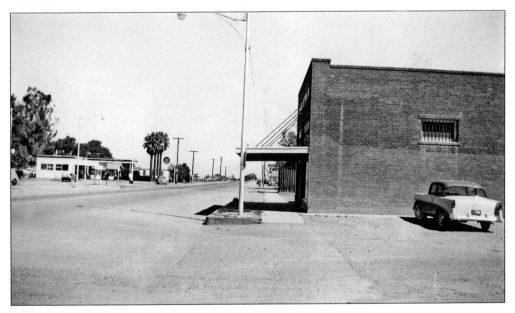

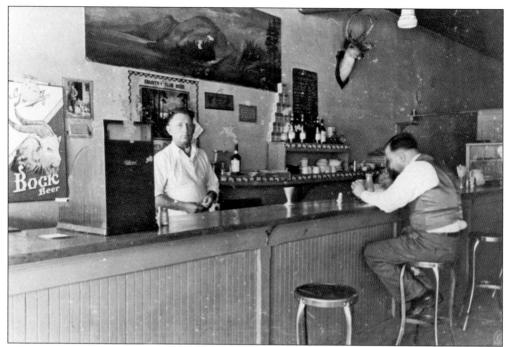

Mickey's Café, owned by Mick Johnson (seen behind the counter), was originally on the west side of Main Street (Gilbert Road), then moved across the street. Seated at the counter is Louis Serrano, who owned Serrano's Popular Store.

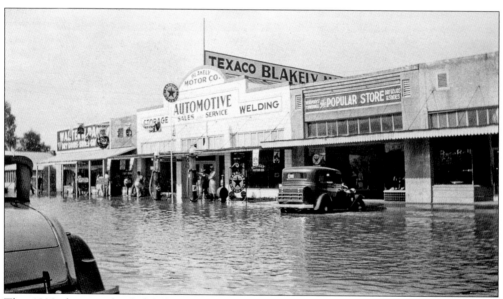

This 1938 photograph of Blakely's Motor Company was taken during one of the several floods in the 1930s. Charles Monroe Blakely started the business in 1929 and sold Ford Model Ts. He later turned the garage into a used-furniture store. He also ran Blakely Ice during the World War II years. His sons Monroe and Vincent started one of the earliest Shell gas stations in the 1930s in downtown Gilbert. They expanded to 40 stations statewide.

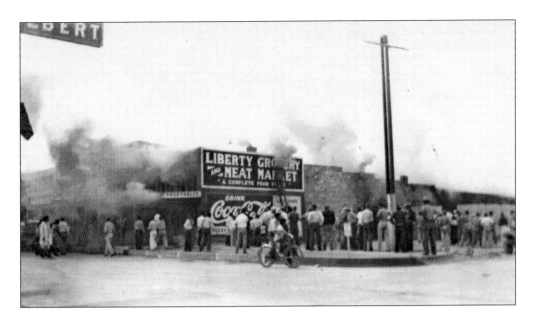

In October 1938, a fire consumed part of the Liberty Market Grocery Store, owned by Eddie and Edith Dong. The fire started in the living quarters at the rear of the building when a gasoline stove exploded. The store was remodeled and enlarged after the fire, making it one of the larger grocery stores in Gilbert. Ben Ong, a Chinese immigrant, began working at the store in 1936. He and his wife, Mae, bought the store in 1943. They doubled the size in 1958 and added a new neon sign, designed by Mae, which is still on the building. Shown below are Ben and Mae and their two children, Joycelyn and Benny.

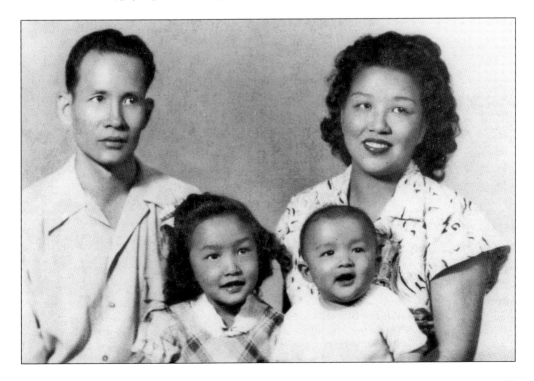

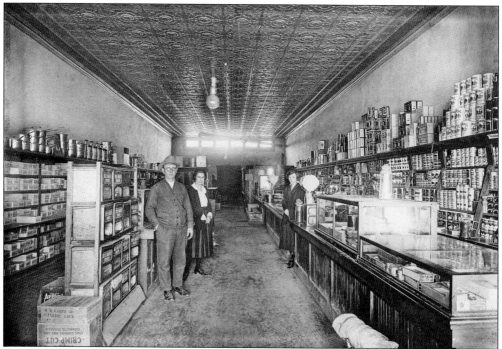

R.R. and Etta Creed and their two children, Pauline and Leslie, came to Gilbert in 1912 and opened the Creed Grocery Store in the 1930s. The building was made of adobe blocks that were created from the earth excavated from the basement. Today, this building is the Farmhouse Restaurant.

Forrest Clare came to Gilbert and built a sheet-metal shop on the east side of Main Street (Gilbert Road) north of First Street (Page Avenue) in 1918. The family home was beside the shop. Clare ran his business for almost 60 years in the same location. The shop was torn down, but the home still stands and is now Bergie's Coffee Roast House.

Oscar Phelps was Gilbert's first marshal and earned $20 a month. In addition to their duties of keeping order, public-safety officials were also the night watchmen for the business district. In 1925, the Gilbert Town Council decided to erect a water tower so pressurized water could be delivered to the new subdivisions. The pump and equipment that maintained the water tower were housed in an adobe block building. Since Gilbert did not have a jail, this adobe pump house became the first Gilbert jail. The pump house is still at the base of the water tower, and there are many interesting stories about people put in jail after a Saturday-night brawl and released on Sunday mornings.

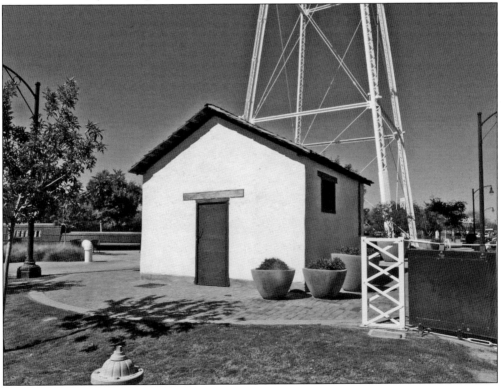

W.C. McConnell became the town clerk shortly after Gilbert's incorporation in 1920. He served in that capacity from 1922 until the 1950s. He also served as a recorder for trials and was sometimes a judge. In addition to those duties for the town, he owned an insurance business for many years. The McConnells played an active role in the establishment of the Gilbert Methodist Church.

Dr. Lucius Tompkins came to Gilbert after World War I and set up his medical practice on the east side of Main Street (Gilbert Road), just south of the railroad tracks. Pictured here are, from left to right, Mick Johnson, Leland Barber, Tompkins, and Les Creed. Dr. William Statler was the next full-time physician in Gilbert, from 1956 through the mid-1980s.

Albert and Mabel Nichols came to Gilbert in 1918. Clabber "Iron Horse" was a quarter horse bought by Albert in 1938. He was more than just a racehorse, as he was used in the fields during the week and would then compete on weekend afternoons. In 1940–1941, he was proclaimed the fastest quarter horse in America. He was inducted into the American Quarter Horse Hall of Fame in 1997. The Nichols family is pictured below. They are, from left to right, (first row) Carrie (married Van Earl Beck), Ola (married John Sawyer), Albert, Mabel, Leatha (married Howard Morrison), and Fay (married Lloyd Bond); (second row) Gilbert (married Ona McClanahan), Buck (married Ruby Payne), Hugh (married Lena Johnson), Artie (married Vesta May Morrison), and Earl (married Frances Latourette). Artie and Vesta May's daughter Neva married Reginald David Beebe, son of Reginald and Mary Rose (Bullard) Beebe, who were prominent farmers in the Higley/Baseline and Recker/Warner areas.

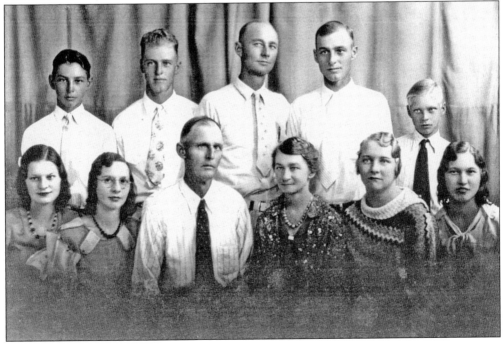

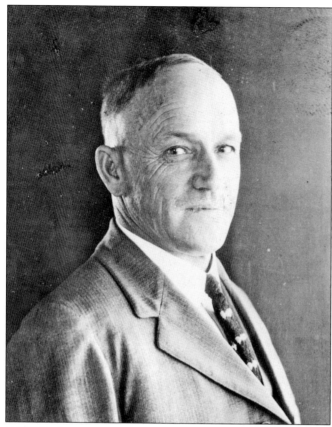

After losing his first wife, C.H. Russell, the businessman who developed Sonoratown, married Mabel Murphy, a home-economics schoolteacher, in 1918. Her classroom (below) was in the basement of the elementary school. It was the tradition in schools at the time that women had to quit teaching when they married. Only single women were allowed to teach in the white school, but men could teach whether married or single. Gilbert was segregated at the time, so there were two other schools—the Mexican school and the black school. Mabel Russell became the teacher at the black school in the old Creed home just south of the Gilbert water tower.

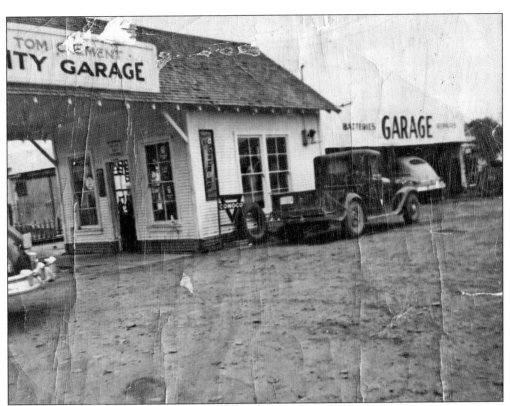

Tom Clement came to Gilbert to manage his cousin's garage and service station in 1934, the same year he married Hilda Palmer. He soon purchased the business and continued to run Clement's Auto Repair for almost 70 years. His sons took over the business, and, in 2015, it is still serving as the oldest continuously operating business in Gilbert. Tom and Hilda had six children—Merlynn, Paul, Tom, Dan, Modena, and David. Tom was mayor of Gilbert from 1949 to 1955 and passed away at the age of 98.

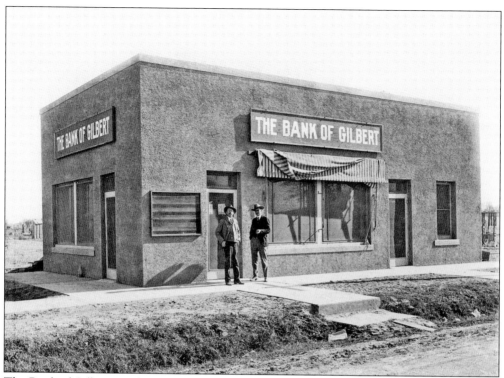

The Bank of Gilbert was built in 1917, and the structure still stands on the southeast corner of Page Avenue and Gilbert Road. The bank had a walk-in vault that is still there, almost 100 years later. Today, the building houses an Allstate insurance agency.

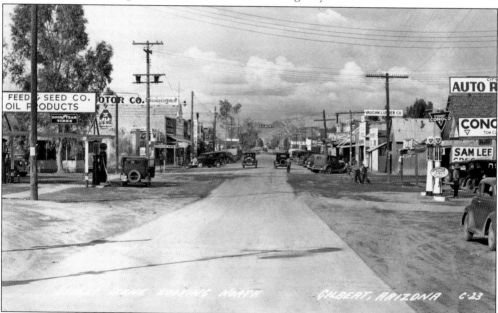

On the left side of this 1935 photograph of Main Street (Gilbert Road) are Capital Fuel, Feed, and Seed, the Page Grocery Store, and the Blakely Garage. On the right are the pumps in front of Clement's Garage, the Sam Lee Market, a welding shop, and Vaughn Lumber Company.

Four

AGRICULTURE AND HOME LIFE

Many early Gilbert residents were farmers who brought their knowledge of farming from other parts of the country and applied those techniques to the dry, parched land of Arizona. The top priority was to dig ditches so water could get to the farmland from the canals. Once they harvested their crops, farmers had to haul their yield to market or to the railroad to ship to buyers. Many moved their produce by wagons pulled by workhorses. Hay, cotton, and cattle had to be shipped by rail.

Cotton and alfalfa were very important crops to the early pioneers. Workers picked cotton by hand and placed it in sacks 7.5 to 14 feet long. It took two to four hours to fill a sack. A good cotton picker could pick 400 pounds a day. In 1933, workers earned only 1¢ per pound of cotton, but by the 1940s, they made 4¢ a pound. After picking, workers dumped the cotton into a trailer where they stomped on it to compact the cotton before pulling the trailer to the ginning factory. The gin removed the seeds and cleaned the cotton.

Rich soil, irrigation, and hard work led to incredible production of alfalfa in Gilbert. Relying on horses, wagons, farm tools, and their own strength, farmers and workers cut hay quickly, raked it, and allowed the hay to dry for baling or stacking. By 1929, farmers were cutting hay up to six times per year and shipping up to 20,000 tons of alfalfa annually. Gradually, technology improved, and farmers used threshing machines to harvest wheat or other grain products.

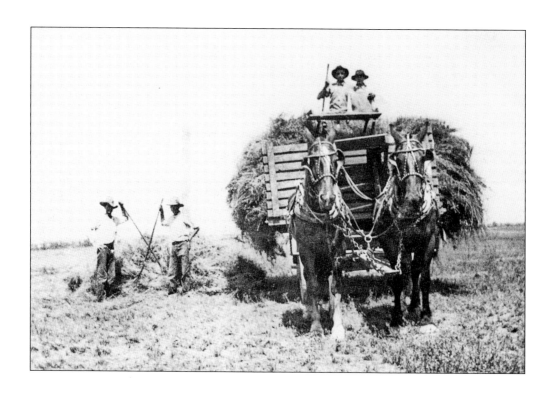

These unidentified men are on top of this horse-drawn wagon loaded with alfalfa hay. These wagons carried large loads of hay to the train depot to be shipped from the Gilbert area. The laborers would pull up right next to the boxcar to load the hay. So much alfalfa hay was shipped out of Gilbert during World War I to supply the cavalry in the United States and Europe that Gilbert earned the name "Hay Shipping Capital of the World."

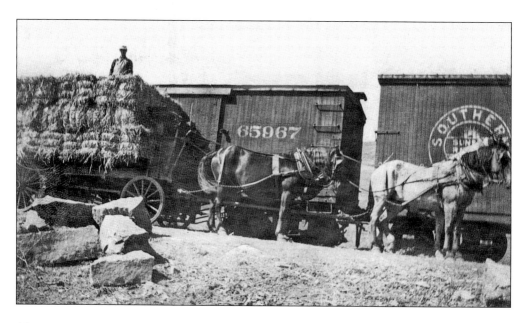

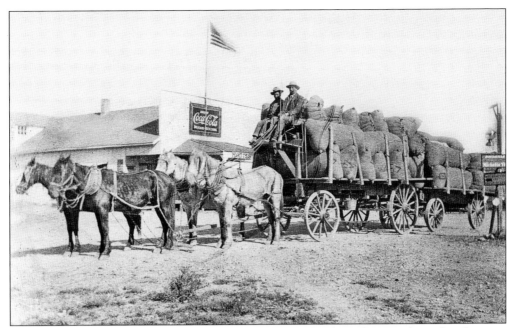

Cotton was another major crop grown in Gilbert and sold to local merchants or shipped out by train. Large horse-drawn wagons and, later, large trucks, carried the cotton through town to the depot. This photograph shows the C.C. Davis Store on the east side of Main Street (Gilbert Road).

Frank Erramuzpe came to Gilbert in the 1930s and married Flora Locarnini. Erramuzpe and his family were Basque ranchers who raised sheep in Gilbert. The sheep wintered in the area but relocated north to cooler pastures on the Mogollon Rim each summer. It was common to see sheep being herded down the streets of Gilbert.

The Waago family dairy farm, located on the north side of Elliot Road just east of Cooper Road, was typical of small family farms in Gilbert in the 1920s and 1930s. Holstein cows produced large quantities of milk that were shipped by rail to mining towns to the east or into Phoenix. Tractors, like the Case tractor seen here, eventually replaced farm animals.

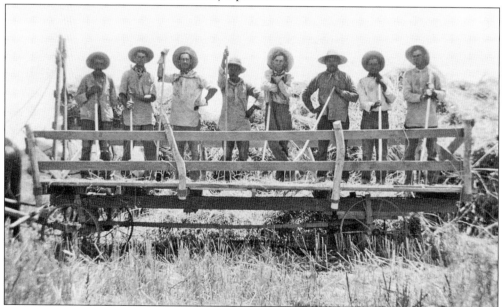

These farm laborers helped harvest grain, alfalfa, and cotton. Many came from Mexico to work in the fields and earn a living. A number of workers assembled on top of this piece of equipment. They were very skilled at working with pitchforks and operating harvesting equipment.

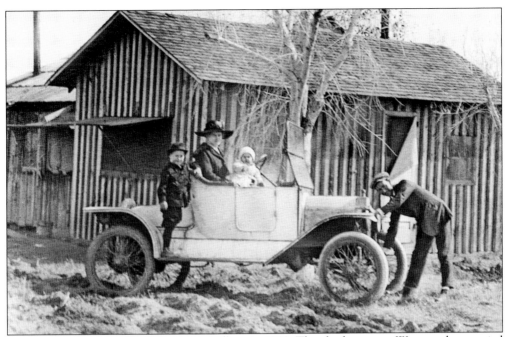

Clyde and Hazel McFrederick came to Gilbert in 1903. They had one son, Wayne, who married Pauline Creed, and one daughter, Mildred. Wayne was a teacher for many years. This car had a crank that was inserted into the engine from the front of the vehicle and then turned until the motor started.

Teeter-totters were built behind the Gilbert Elementary School soon after it opened in 1913. This 1918 photograph shows Mildred Barkley (left front) and Hap Nowell (right front) at recess.

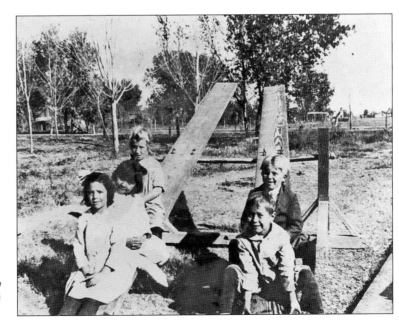

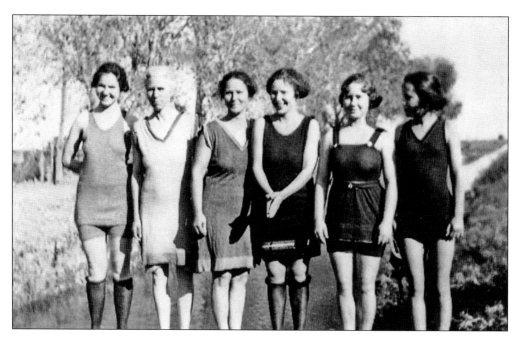

On Christmas Day 1923, these women were at the Gilbert hot pump enjoying the warm water that was pumped directly from a hot spring in the earth below. Pictured above, from left to right, are Mary Louise (Willcox) Skinner, Etta (Lord) Creed, Mary (Meason) Nowell, Jewell (Nowell) McFrederick, Georgia (Nowell) Sedberry, and Pauline (Creed) McFrederick. The cottonwood trees in the background grew along the canal bank until the 1960s, when they were removed because they took too much water from the irrigation canals. Below are unidentified people enjoying the Consolidated Canal with a pump house in the background.

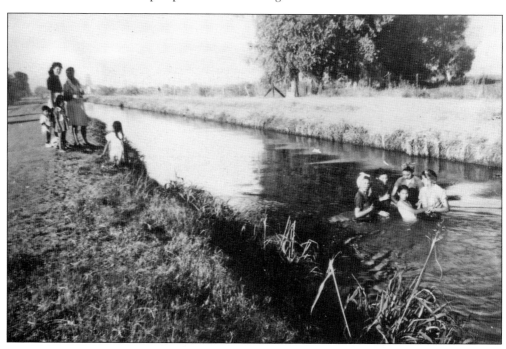

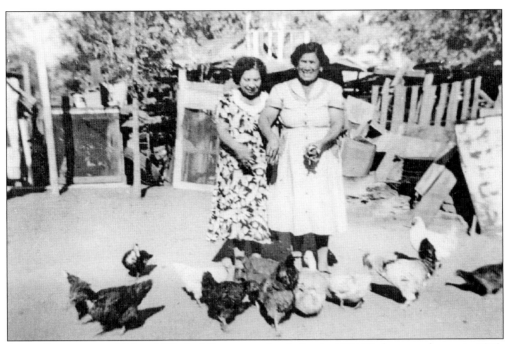

Anita Castro married Miguel "Tacho" Figueroa, a hay baler, in 1927. Tacho passed away in 1943, and Anita raised their four children—Mike, Angelito, Carmella, and Victoria—on her own. They all attended the Mexican school. Here, Anita (right) and her sister Vidal are shown with some of the chickens they raised for food and eggs.

The Locarninis came to Gilbert in 1913 and lived on the west side of Gilbert Road half a mile south of Baseline Road. Here, Joe Locarnini poses with his six children—from left to right, Laurence, Flora (Erramuzpe), Josie (Gonzalo), Charley, Ida (LaPella), and Mary (Invernizzi).

The photograph above shows the John L. Anderson home in the summer, when it was completely engulfed in trees, leaves, and vines to cool it from the heat. The photograph below shows the Hoffman home, where the family slept on the porch to stay cool. The Hoffmans, who came to Gilbert in 1900, lived on Baseline Road just west of Gilbert Road. Charles Hoffman served on the Gilbert School Board when the Gilbert Elementary School was built in 1913. Ross Lacy, one of the Lacy family for whom the second subdivision in Gilbert was named, married Ethel Hoffman.

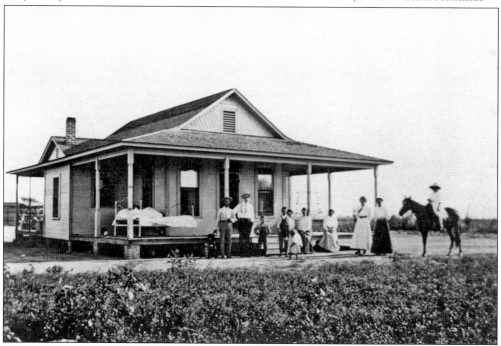

The Pine residence, at the southwest corner of Guadalupe and Gilbert Roads, was one of the only brick homes in Gilbert. Charles and Mary Pine built this house, but it was their son Alfred and his wife, Marian Bond, who lived in the home and raised their three children—Bonnie (Amster), Elaine (Lamb), and Stanley, all of whom still live in the area.

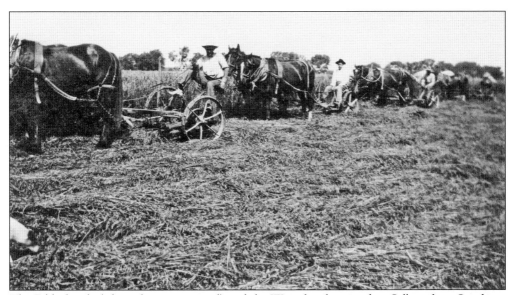

The Eddy family (whose farm is pictured) and the Ware family moved to Gilbert from Southern California in 1918. Hannah Eddy and Frances Ware were sisters. They came by train with their farm animals, equipment, wagons, and household belongings. They unloaded everything in Maricopa and traveled by wagon to Gilbert, where they lived in tents by the canal until the land was cleared and their homes were built near Gilbert and Warner Roads.

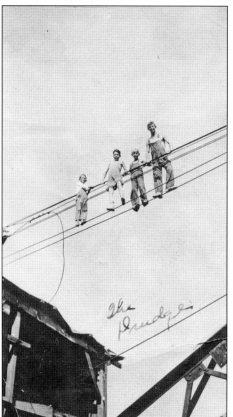

Clifton and Juanita Hallock came to Gilbert in 1936 from Oklahoma and raised seven children. He worked at the Roosevelt Water Conservation District as a heavy-duty mechanic, and she worked at the Gilbert Post Office for over 20 years. Later, Hallock and his son Dennis owned and operated the Gilbert 76 Union Station for 25 years. Pictured here are, from left to right, (first row) Jill (Huey Goldby), Verna Jo "Jody" (Gomez), Juanita (Bowling) Hallock, Kenneth, and Clifton; (second row) Dennis and his wife, Betty (Clark) Hallock, Geraldine and her husband, James Albert Nichols, Dale, and Violet. James Albert was the son of James and Maude May (Keener) Nichols and the nephew of Albert Nichols, who is mentioned on page 41. His siblings were Ira, Olive, Lawrence, Edith, and Artie.

Dr. A.J. Chandler, for whom the city of Chandler was named, used dredges to excavate and maintain the Consolidated Canal from Mesa through Gilbert on its way to Chandler. In this 1923 photograph, these young boys are walking on the cables of one of the dredges. They are, from left to right, John Freestone, Earl Warren, Louis Crandall, and Alfred Freestone.

Clyde Neely was the second-eldest son of W.H. and Eula Neely. Clyde and his wife, Minnie Mae, moved to Gilbert from Texas in 1924. Clyde was a farmer from 1924 until his death in 1953. After Minnie Mae's death at the age of 49, Clyde married Mildred King and then Sarah Cobb. Clyde was president of the Maricopa County Farm Bureau and the Arizona Farm Bureau and served on the Salt River Project Board of Governors. He started the Chandler Ginning Company and was a member of the Mesa First Baptist Church. Clyde and Minnie Mae's six children are shown below: from left to right are (first row) Rex, June (Morrison), and Margaret (Weldon); (second row) Warren R. "Jake," C.W. "Buck," and Lorena (Brown).

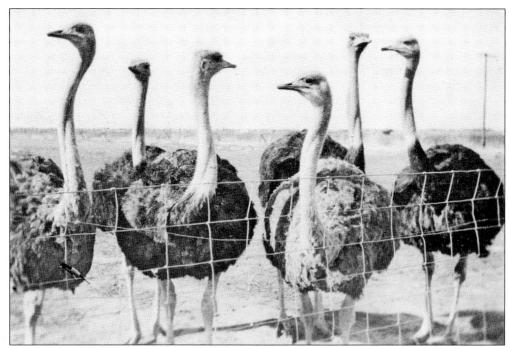

The Spanglers raised ostriches on their ranch on Guadalupe Road, between Gilbert and Cooper Roads, in 1910. Ostrich feathers were used in women's hats and scarves. The Ernest Ellsworth family lived on the ranch and tended the ostriches. Bud Stiles delivered ostrich eggs to the new San Marcos Hotel in Chandler. Each egg was equal to a dozen or more hen eggs.

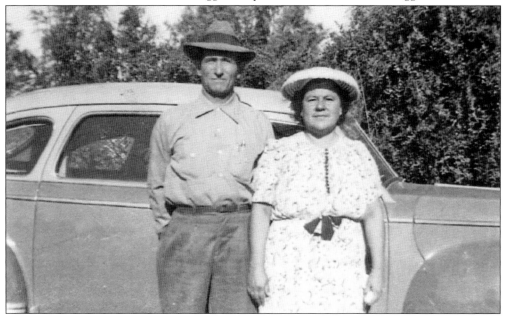

William Carrillo came to Gilbert in 1917, married Vera Pesquera in 1922, and raised four children. In addition to being a farmer, he helped build the first St. Anne's Catholic Church. He later built Carrillo's Camp, which provided low-income housing for Mexican Americans and "Okie" families during the Great Depression.

Five

CHURCHES AND SCHOOLS

Schools and churches were important to the stability of this new community. Pioneers were willing to donate land and money to build schools for their children. Most of the early settlers came from the Midwest and were well educated for this time period and knew the value of education. The first two schools built in the Gilbert area were still part of the Mesa School District. The first school, a one-room timber building, was constructed in 1900 at the southeast corner of Baseline and Cooper Roads. Students had to travel quite a distance and usually rode horses or drove wagons to get to school. The first schoolhouse was used until 1909, when a block building was erected on the northeast corner of Guadalupe and Cooper Roads a mile to the south.

There are three public school districts in Gilbert. The Gilbert Public School District No. 41 was formed in 1913 with the opening of the Gilbert Elementary School on the southwest corner of Elliot Road and Main Street (Gilbert Road). The first Gilbert High School was built in 1918–1919 and opened in 1920. However, in 1909, what is now known as the Higley Unified School District opened Higley Elementary School as a school offering kindergarten through eighth grade and serving 26 students in the East Valley. Part of the Chandler Unified School District also lies in the town of Gilbert. The first church building in Gilbert was the Church of Christ, erected in 1914. In 1918, both the Church of Jesus Christ of Latter-day Saints (LDS or Mormons) and the Methodists constructed their first church buildings. Each of these three groups met on the steps of the elementary school prior to having their own buildings. The first Catholic mission was built in 1936 and the Baptist church in 1943. By 1945, five churches had been established in a community of less than 1,000 people.

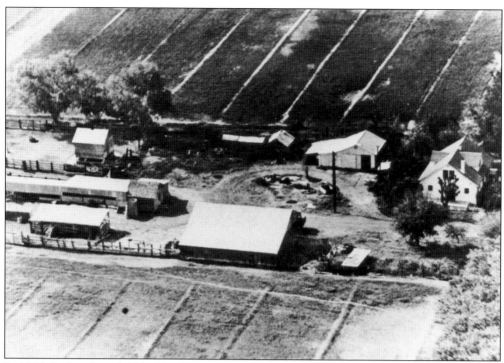

In 1915, Arthur S. and Abby Haymore moved to the Gilbert area from Mexico. They and other Mormons were driven from Mexico by Pancho Villa. Although one daughter died in Mexico, the Haymores arrived in Gilbert with eight other children and began reorganizing their lives. Six more children were born after their arrival in Gilbert. They built their dairy farm, shown here, on Baseline Road near Horne Street. Arthur also helped establish the LDS church in Gilbert. In 1918, Arthur was called to be the bishop of the new Gilbert Ward and immediately began building the first Mormon church in Gilbert.

Dave and Ruth Lamoreaux moved to Gilbert from Utah in 1925. They had four children and were active in the LDS Church. Dave was a soil-conservation supervisor. At the age of 50, he became a pilot and member of the sheriff's air posse and the Flying Farmers. Pictured are, from left to right, (first row) Alvin, Ruth, and Dave; (second row) Vida (Hatch), Tenney, and Edna (Cotter).

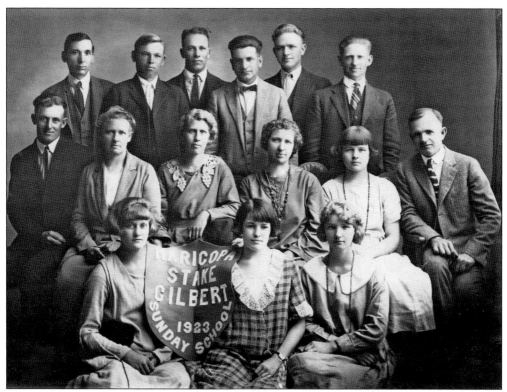

This is the Maricopa Stake Gilbert 1923 Sunday school, Church of Jesus Christ of Latter-day Saints. Pictured are, from left to right, (first row) Nina Nichols, Loree Crandall, and Inez Haymore; (second row) Paul Crandall, Ellen Viola Nichols, Ellen Elva Sabin, Grace Johnson, Barbara Allen, and Price Brinkerhoff; (third row) Rosel Cooley, Robert Manning, Orville Vance, Freeman Cooley, Loren Allen, and Alfred Nichols.

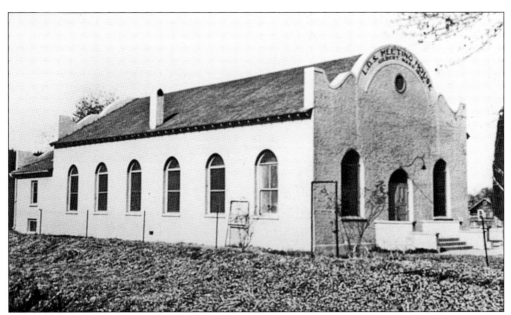

The first local LDS church was built in 1918, on the northwest corner of Elliot Road and Main Street (Gilbert Road). It was built of adobe block and called the Adobe Ward Building. In 1947, a large expansion was made, adding a sanctuary to the north of the original structure. A new chapel was added in the 1960s. The entire expanded ward building was later used as a Boys and Girls Club before the structure was torn down in 2007.

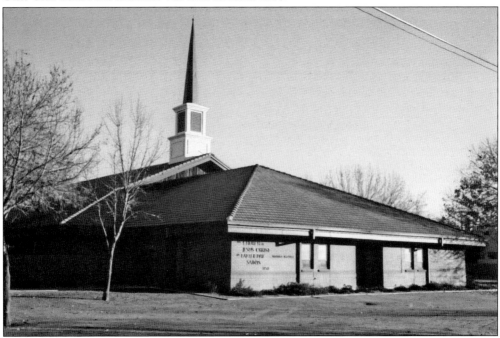

The LDS community in Gilbert has grown significantly through the years. Modern LDS ward buildings hold approximately 450 to 600 members in each ward and accommodate three wards at staggered times each Sunday. There are usually six to nine wards in a stake. The stake building can hold 1,200 members at a time, and there were seven stakes in Gilbert in 2014.

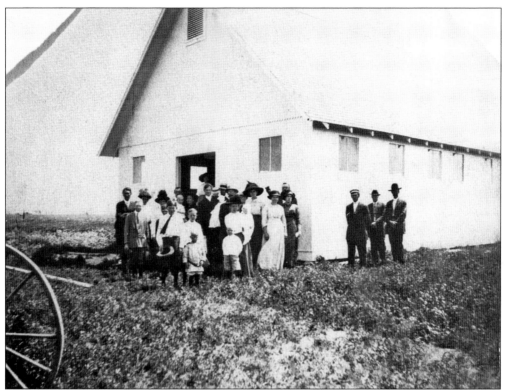

The first church in Gilbert was the Church of Christ, built in 1914. It was located a block east of Main Street (Gilbert Road), on Central Avenue (Cullumber Avenue). Amos and Cora Burk donated the land for the church building and were active in helping to finance the church. Also a moving force in getting the Church of Christ started, Claude Cullumber (pictured at right), for whom the street was eventually named, was a clothier in Gilbert who later worked at Serrano's Popular Store and also served as the fourth mayor of Gilbert, from 1923 to 1925.

The Amos and Cora Burk home (above), built at the northeast corner of Gilbert and Elliot Roads, consisted of six rooms and a large front porch. The home was well maintained over the years and eventually relocated to its current site north of the post office on Elliot Road. Amos had two prize Brown Swiss bulls (pictured below). Tragically, one of the bulls, Jumbo, gored him to death in 1913. After Amos passed away, Cora married a widower named G.W. Lines in 1915. Cora continued living in the home until her death in 1943.

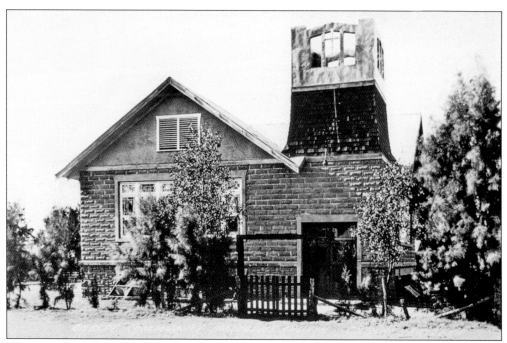

The First United Methodist Church was established in 1918 one block west of Main Street (Gilbert Road) on Second Street (Vaughn Avenue). The church had a high loft and a walk-through entrance in front of the building. There was a basement where choir practice was held. This building served the church for many years before it was condemned. A new chapel was built on the west side of Main Street south of the present school-district offices. This second church building was sold when a new church building and activity center (below) were constructed on Cooper Road, a quarter of a mile south of Elliot Road, in 1990.

Raymond and Etta Creed (left) and Howard and Leatha Morrison (below) were instrumental in the establishment of the Methodist church in Gilbert. The Creeds came by train to Gilbert in 1912 and opened the Creed Grocery Store. Leatha Nichols came to Gilbert with her parents from Cheyenne, Oklahoma, in 1918. Her future husband, Howard, came to Gilbert from Oklahoma in the following year. When Morrison arrived in Gilbert, he worked for $1.50 a day and was still earning that wage when he married Leatha in 1921. The Morrisons became substantial farmers in the Gilbert area and were stalwarts in the early Methodist church. (Below, courtesy of the Morrison family.)

St. Anne's Catholic Church was originally an adobe mission on Bruce Avenue constructed in 1936. Shown here in the 1940s, the mission officially became St. Anne's when the first resident priest arrived in 1943. St. Anne's established the first kindergarten in Gilbert. Prior to this kindergarten, students in Gilbert did not go to school until they were six and began the first grade.

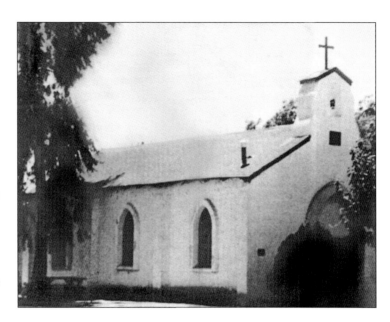

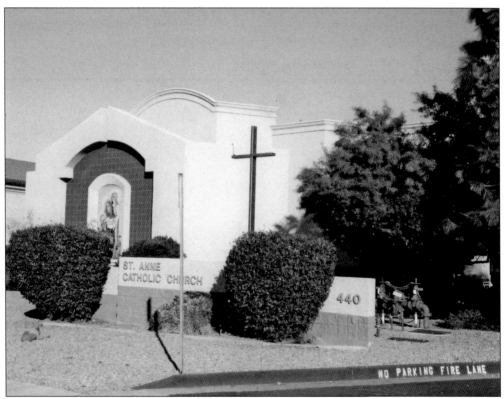

The congregation of St. Anne's Catholic Church grew steadily, and a larger building was built in 1971 next to the church on Bruce Avenue. In 1988, ground-breaking began for a new building on Elliot Road east of Gilbert Road. The first mass was held in the new sanctuary in 1989. Early members of the church on Bruce Avenue included the Figueroas, the Bernals, the Erramuzpes, and the Padillas.

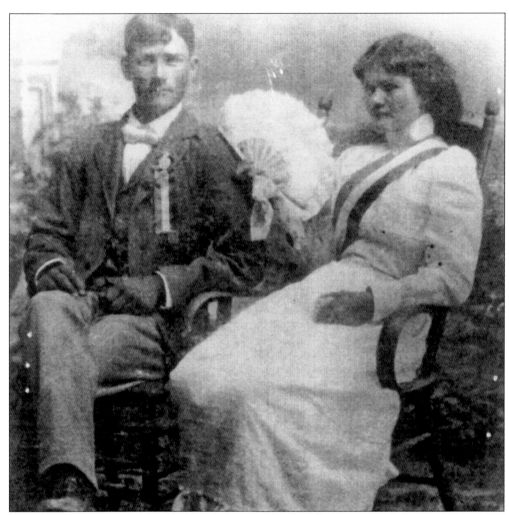

Ramon and Clara Bernal founded hay-baling and hauling businesses as well as a grocery store and a butcher shop. Clara was from Tempe and Ramon from Nogales. They married in 1901 and lived in Tempe until 1915, when they moved to Gilbert. Ramon and Clara had 11 children—Juana, George, Ramon, Francisco, Manuel, Rosenda, Maria, Eugene, Estefana, Sara, and Eraclio. Their third child, Ramon, known as Ray, married Adela Saiz. He took over the hay-baling business from his father. Ray and Adela worked with others to end segregation in the Gilbert Public Schools and succeeded when the Mexican school closed in 1949. Ray and Adela had 10 children—Ramon, Esther, Margaret, Clara, Andrew, Joe, Mary, Frank, Christina, and Conrad. Ray's brother Manuel married Anna Horta. They had seven children—Grace, Armida, Sylvia, Carmen, Lupe, Manuel, and John. Manuel had a hay-hauling business, and Anna was very active at St. Anne's Catholic Church. Their sister Rosenda married Ignacio "Nacho" Talamante, and they had six children—Ignacio Jr., Josephine, Margaret, Cruz, Jerry, and David. Many of these descendants still live in the valley.

There were a number of First Baptist Church members in Gilbert before a home was purchased on Ash Street in 1943 and converted into a church building. The first Vacation Bible Schools in Gilbert were conducted in that early building. In 1948, the membership outgrew the small church house, and members constructed a large church building on Main Street (Gilbert Road) just north of Second Street (Vaughn Avenue). In 1999, an even larger building (above) was erected on the northwest corner of Recker and Elliot Roads, and the name was changed to Gateway Fellowship. Today, there are several Baptist churches in Gilbert. The Ellis family (below) was very involved with the growth of the Baptist church in Gilbert.

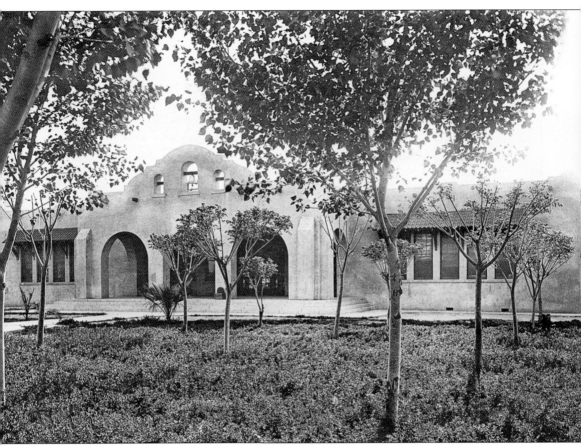

In 1913, the Gilbert Elementary School was built at the southwest corner of Main Street and Elliot Road on land donated by Everett Wilbur, Gilbert's first mayor. This was the third school in Gilbert, but the first school in the new Gilbert School District No. 41. This first official Gilbert School had four classrooms and an auditorium. There was no air-conditioning or inside plumbing, but there were two outside toilets. A well south of the building provided fresh water, and a furnace in the basement provided heat in the winter. Approximately 85 pupils attended the school. In 1917, a north wing was added with two classrooms in the basement and two rooms above them. In 1925, a south wing was added with two more classrooms. By 1931, the number of students had risen to 281. In 1940, a new building was constructed to the west of the south wing, adding two more classrooms. This school closed for classroom use in 1977 and reopened in 1982 as the Gilbert Historical Museum. It is the only building in Gilbert listed in the National Register of Historic Places.

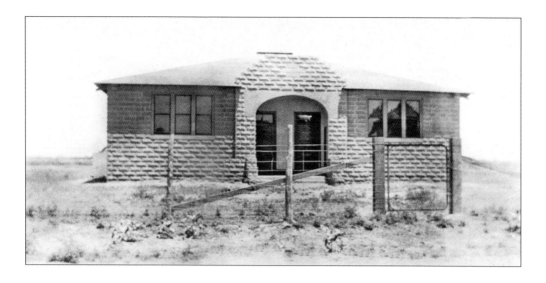

Constructed in 1909, the second school built in Gilbert, pictured above, was also called the Highland School and was part of the Mesa School District. In 1927, the Gilbert School Board segregated the Mexican children to help them learn English. The "Mexican school" was established, but in 1949, at the urging of many parents, the school board agreed that the original goal of segregation had not been met. Segregation was abandoned, and the schools were integrated. For a number of years, there was also a school solely for black children, located in a house at the base of the water tower. Pictured below in 1945 and facing Main Street (Gilbert Road) is the entire school complex. From left to right are the Mexican school, the gymnasium, the two-story high school, tennis and basketball courts, and the elementary school.

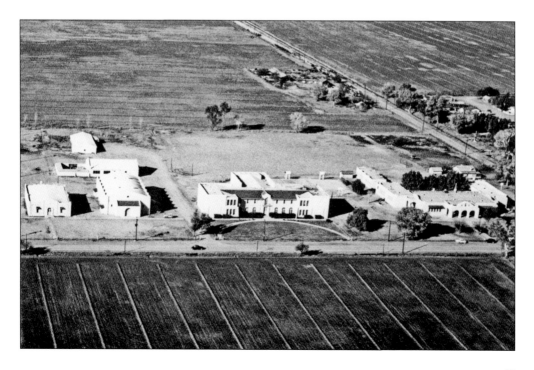

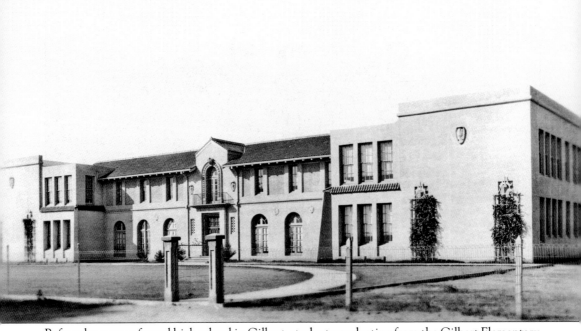

Before there was a formal high school in Gilbert, students graduating from the Gilbert Elementary School went to Mesa High School to receive their high school diploma. In 1915–1916, Gilbert elementary teachers began teaching high school students as well. In 1918, at the urging of the only four soon-to-be-graduated seniors, Gilbert decided to add a high school of its own. The first students to receive a diploma from Gilbert High School were Myrtle Lines, Elvin Lines, Linda Marsh, and Gertrude Brookins in 1918. Large tents were placed in front of the elementary school because the high school building was not completed until 1920 (at a cost of $125,000). In March 1938, the school's new shop building, auditorium, and gymnasium were completed. The first high school building in Gilbert is now home to the Gilbert Unified School District administrative offices. As of 2015, there are 26 elementary schools, six junior high schools, five high schools, and four specialty schools in the district that serves almost 40,000 students.

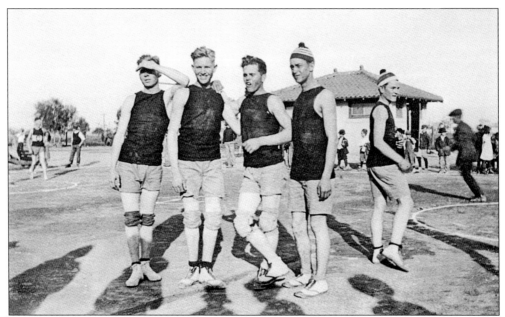

From their inception, Gilbert schools have always had athletic teams. In 1927, the boys' basketball team finished fifth in a national tournament in Chicago, Illinois. This was quite an accomplishment, as the team had to beat Phoenix to go to the tournament. The 1918 team shown above includes, from left to right, Edwin Miller, Larry Allen, Orin Fuller, Carroll Brown, and Merrill Hatch. Having a girls' basketball team at all in 1924 was quite progressive for the day. Uniforms for both boys and girls were fairly conservative. In this photograph of the girls' team are, from left to right, Coach Wallace, Charlene Bentley, Leota Neely, Irene McCreary, Gladys Barnes, Nina Nichols, Delia Freestone, and LaVon Rust.

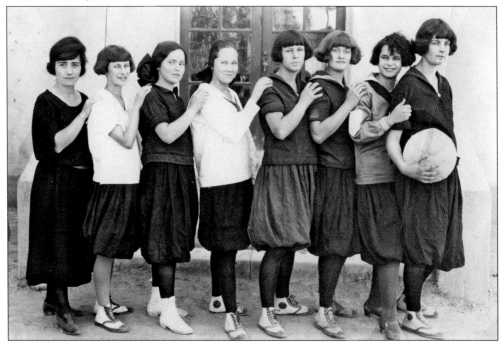

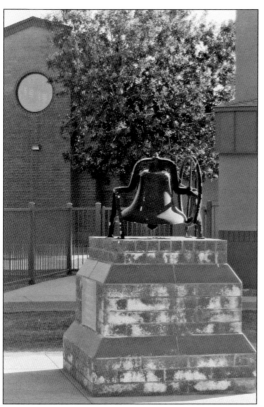

Although first opened in 1909, the Higley Elementary School, a kindergarten through eighth grade campus, had 175 students attending in 1998. In 1999, the Higley Unified School District was officially established by the voters. By 2010, there were eight kindergarten through eighth grade schools and two high schools in the district. Higley Elementary was converted to the Higley Traditional Academy. A bell from the original school (left) sits in front of the library of the academy. In 2013, all kindergarten through eighth grade schools changed to offer kindergarten through sixth grade, and the district opened two junior highs and two early-childhood development centers. The Higley Center for the Performing Arts (below) is owned by the Higley School District and opened in 2006. It has a concert hall–style theater that seats 1,235 people and a smaller theater that seats 186. The Higley Center promotes national touring groups, serves the community and the school district, and offers facility rental opportunities. (Below, courtesy of HUSD.)

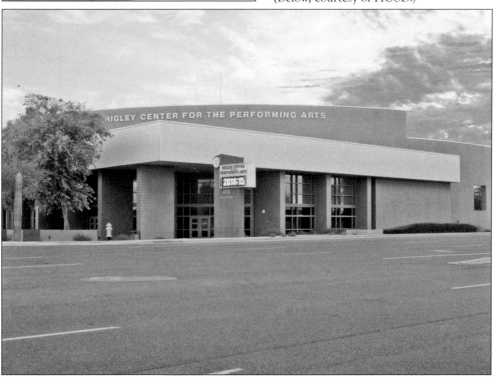

Six

WORLD WAR II AND GILBERT

Gilbert, Arizona, was greatly affected by World War II. Many young men, some just out of high school, felt it was their duty to serve their country. Gilbert's downtown area had 847 people in 1940, but the surrounding farming community brought the population to over 2,000 and was still growing. From 1941 to 1945, approximately 1,000 men and women from Gilbert served with honor. Eight of those Gilbert men gave their lives for our country—Henry Angle, Delbert Artherhold, Leonard Bohannan, Nick R. Davis, E. Rex Goodman, Meredith Miller, Carl J. Needham, and Ramiro B. Quintero. The names of those who served from Gilbert are on a monument in front of the Gilbert Historical Museum at the southwest corner of Elliot and Gilbert Roads.

Some of Gilbert's families had several children that served as enlisted men or noncommissioned officers and some as officers in the Army, Navy, Army Air Corps, Marines, and the Coast Guard. The Army Air Corps became the Air Force in 1947, two years after World War II was over. Elvis and Gracie Lemons had four sons who served in the war—Eugene, Clarence, Lois "Sugar," and Ray. The only female from Gilbert to serve was Ethel Wilbur Mastin, daughter of the first mayor, who served in the Navy WAVES. Bill Wallace, after graduating from Gilbert High School and attending Arizona State Teachers College, was selected to be a Coast Guard officer. Wallace gave Gilbert the recognition of having men in every branch of the services that existed during World War II.

Joe Wilbur and Bill Mastin came home as trained pilots and started the Wilbur Flying Service and the Gilbert Airport.

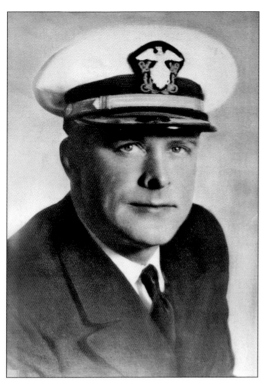

The family of Emil Gieszl had four sons who served in World War II. The eldest was William Joseph Geiszl (left), who was a member of the US Navy. Next in age was Carl Raymond Gieszl (below), who also joined the Navy. In 1912, the family moved from Kentucky and homesteaded in Queen Creek. There were also four girls in the family—Rose, Christine, Madge, and Ruth. Rose became one of America's Rosie the Riveters in an airplane factory.

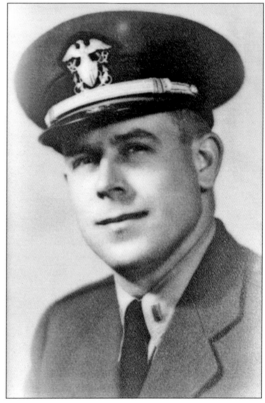

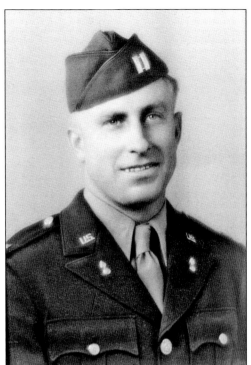

In 1915, the Gieszl family moved to Gilbert, and all eight of their children attended Gilbert schools for at least part of their education. Hugh Lynn Geiszl (right) joined the US Army. The youngest son, George Scott Gieszl (below), became a captain in the Army. He and three of his company captured 49 Germans at one time on the western front. All four sons became officers and served through World War II.

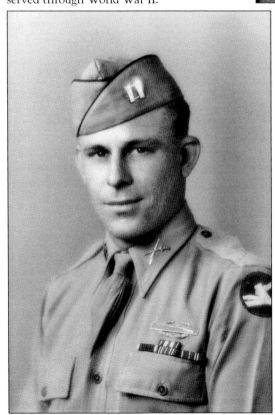

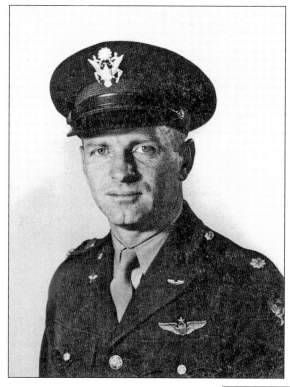

Everett Wilbur was the first mayor of Gilbert and led the town when Gilbert incorporated in 1920. Two of the sons of Everett and Nelly Wilbur joined the military service during World War II. Walter Wilbur (left) was in the Army Air Corps and became a lieutenant colonel. Joseph H. Wilbur (below) joined the Army and became a corporal. He returned to Gilbert and started the Gilbert Airport with his brother-in-law Bill Mastin. They offered flight training and a ground school for private and commercial pilots and flight instructors. After a few years, business tapered off and the school closed.

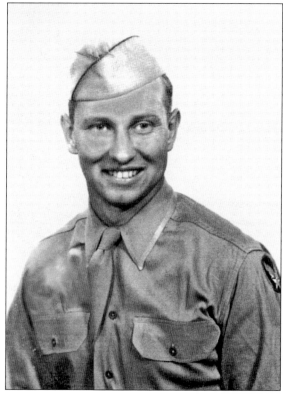

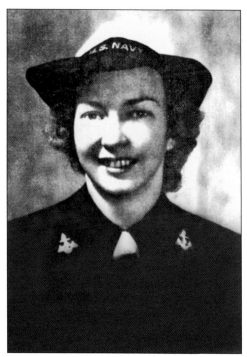

Ethel May Wilbur (right) married Bill Mastin on Christmas Day in 1942. Because her brothers Joe and Walter and her husband, Bill, were all serving in the military, Ethel decided that she, too, would join the war effort. She chose to be a WAVE in the US Navy and became a second-class storekeeper. After World War II, Bill (below) started the Gilbert Airport and taught flight training. In addition to being a flight instructor, Bill was a crop duster, worked for the post office for 28 years, and became an accomplished photographer. Bill and Ethel had four children—Betty, Diane, Brian, and Susan.

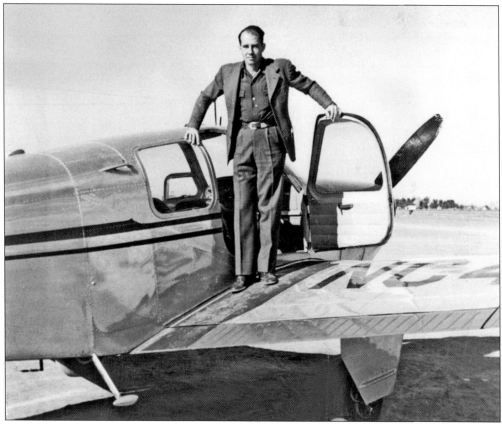

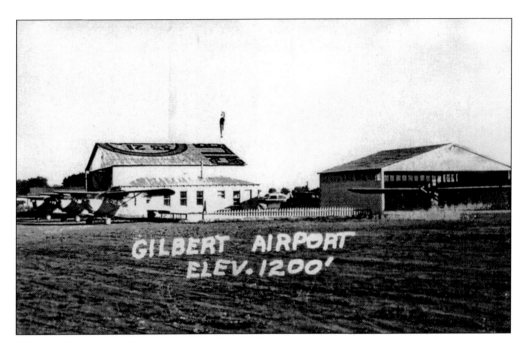

The Gilbert Airport was located where the Mesquite Aquatic Center now stands. One of the many people who learned to fly airplanes at the Gilbert Airport was Darrell Sawyer (below). Sawyer is the son of John and Ola Nichols Sawyer. He married Dorothy Mills, also of Gilbert, and flew for Air Evac, rescuing and saving the lives of many in outlying communities. Sawyer founded Sawyer Aviation in Phoenix in 1961, primarily as a flight school, and it grew in size and reputation for many years.

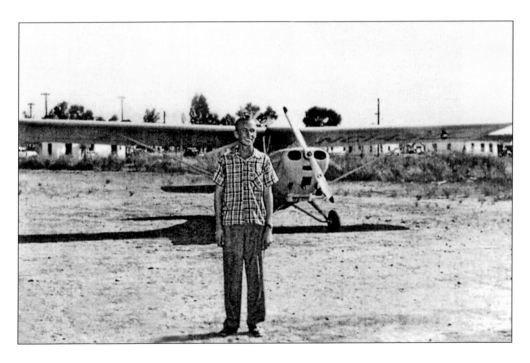

Marvin Morrison, son of Howard and Leatha Morrison, joined the US Army and fought at the Battle of the Bulge. He married June Neely in 1944 and they enjoyed almost 63 years of marriage until his passing in 2007. Upon returning to Gilbert in 1946, Marvin and his brother, Kenneth, who served in the US Navy, started Morrison Brothers Ranch. The business grew to include a cotton farm, dairy, and cattle ranch. Marvin was twice recognized as Man of the Year in Arizona agriculture. June and Marvin were very civic minded; both served as president of the Chandler Regional Hospital Board, and Marvin served on the Gilbert School Board for 14 years. Marvin received many awards and served on many local, state, and national boards in the fields of agriculture and business. He was also known for his civic and charitable involvements outside of agriculture. Marvin and June provided charitable contributions all over the East Valley. June and their three sons—Richard, Scott, and Howard—still live in Gilbert. (Courtesy of the Morrison family.)

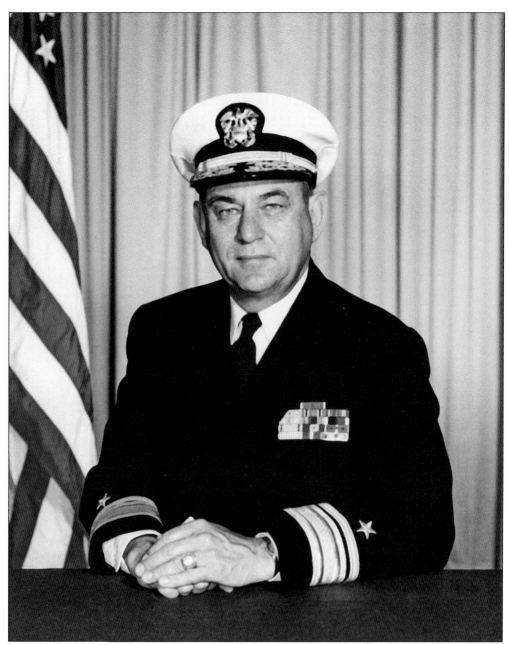

A descendant of the original pioneering families in Gilbert, Raymond W. Burk graduated from Gilbert High School in 1938 and joined the US Navy. In 1939, while he was still an enlisted man, he served on the USS *Arizona*. In 1940, he was given the opportunity to attend the Naval Academy Preparatory School, which aided him in passing the entrance exam to become a midshipman at the US Naval Academy in Annapolis, Maryland. Burk eventually reached the rank of rear admiral, which is the highest-ranking officer position of any graduate from Gilbert High School to date. He retired in 1976 and went on to become the San Diego port commissioner. The Burk name is found throughout Gilbert, including on Burk Street and Burk Elementary School. Admiral Burk's funeral in January 2008 was held at the USS Midway Museum in San Diego.

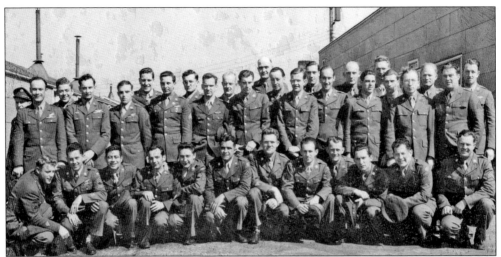

Cecil Webster (second row, second from right) was an airplane mechanic in the Army Air Corps. Webster also served as volunteer fire chief of Gilbert in 1962.

Jim Nunn, pictured here in 1938, was in the US Army Horse Cavalry. During World War II, Nunn was a company commander, 82nd Airborne Division, and, as a paratrooper, jumped on June 7, 1944, D-day, over Normandy. Originally from Texas, Nunn was stationed at Williams Air Force Base in 1948 and soon afterward made his home in Gilbert. He was the director of public works for the town in the 1960s.

Ellis Hills was a private first class in the US Army during World War II. He was awarded the Bronze Star in 1997 for his service in ground combat. His son Clarence S. Hills served in Vietnam and also was awarded the Bronze Star for heroism in ground combat in 1968. Tragically, Clarence died in combat later that same year.

Cecilio and Margarita Rosales came to Gilbert in 1935 from Oklahoma. They had 13 children (six boys and seven girls). During World War II, five of their sons were in the service, and all survived. One of those sons, Willie, became the first Mexican American policeman in Gilbert in the early 1960s and also the first to serve on the town council. The Rosales family loved music, and almost all of the children played an instrument.

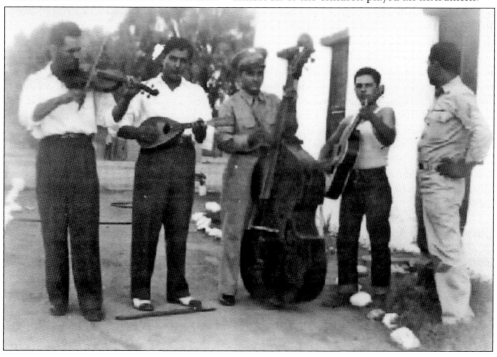

Seven

BEFORE EXPANSION

From the post–World War II years until the late 1970s, Gilbert was a simple farming community that saw its population more than double. There were 837 people in Gilbert in 1940, then 1,114 in 1950, a jump to 1,833 in 1960, and 1,971 in 1970. As modern conveniences of life were developed, the citizens made improvements that made life easier. For example, a sewer system was installed in 1949. It is hard to imagine that prior to 1950, every family in the area had a privy or outhouse in the back of its home. Some main streets were paved in 1956. Gilbert got its first stoplight in 1973 at Gilbert and Elliot Roads. All of these things unknowingly began preparing Gilbert for the growth that was to occur in the next several decades.

In 1971, the Superstition Freeway was extended from Phoenix to the East Valley. This freeway would begin to open the entire East Valley to expansion, but in the early years, it was not seen as something that would eventually help put Gilbert on the map. The freeway was considered outside of Gilbert, as the north end of Gilbert was the Western Canal, and the freeway was two miles north of that point. The first section, from I-10 to Mill Avenue, opened in 1970. By 1981, the freeway extended to Gilbert Road.

Gilbert Estates was the first modern subdivision to be built in the 1950s. Located south of Elliot Road just west of Gilbert Elementary School, three-bedroom, two-bath homes had block construction and could be purchased for $10,000 to $11,500. Town amenities like the Gilbert Library and the swimming pool were built with funds raised from private donations, bonds, carnival celebrations, and door-to-door solicitations.

By 1971, Gilbert decided to expand its town council from the five members it had been since 1920 to seven. Probably the most significant action taken by this council was the strip annexation of 53 sections that gave Gilbert land for future development. Dale Hallock was a young mayor (only 36 years old) at the time, and he led the council in securing the land that has made Gilbert into the growing, thriving community it is today.

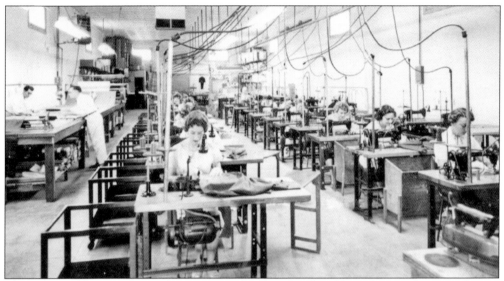

The Tone Building, on the northeast corner of Gilbert Road and Page Avenue, has served many different businesses through the years. It hosted Gilbert's first movie theater when a candy bar was a nickel, then a shoe factory, a deli, and, as shown in this photograph, a shirt-manufacturing company in the 1970s.

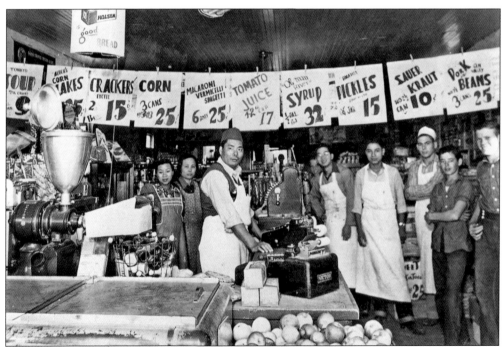

Sam Lee's Grocery was on the southeast corner of Central Avenue (Cullumber Avenue) and Main Street (Gilbert Road). Sam and his wife and children ran the operation. There was a full basement, where canned goods were stored until they were needed to stock the shelves. Today, this site is a parking lot.

From the 1940s through the 1970s, the post office was on the east side of Main Street (Gilbert Road) next to the Gilbert Barber Shop. Winnie Johnson was the longest-serving postmistress in Gilbert. This 1975 photograph shows the post office with the Western facade adopted by many businesses.

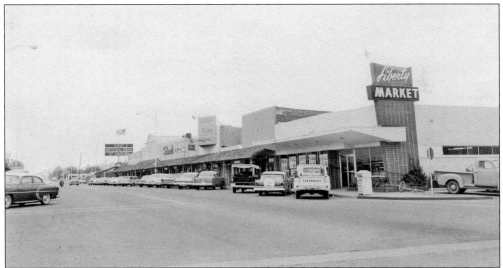

This photograph shows Liberty Market in 1961. The Ongs sold the market to Sam and Betty Brommert in 1981, who sold it to Joe and Cindy Johnston and David and Kiersten Traina in 2006. It opened in 2009 as a very popular urban bistro appropriately named Liberty Market.

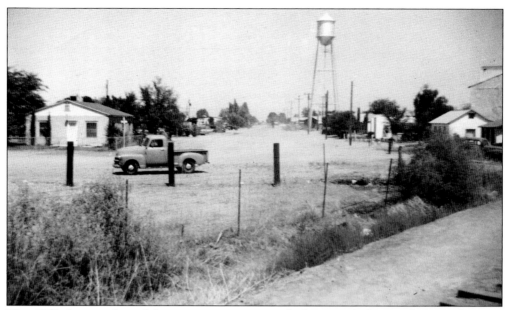

This 1956 photograph is of the water tower in a view looking north down Ash Street from the railroad track. The street sign on the left of the pickup shows an extension of Central Avenue (Cullumber Avenue). The water tower has been different colors through the years—black, silver, white—and now has the name Gilbert written on it.

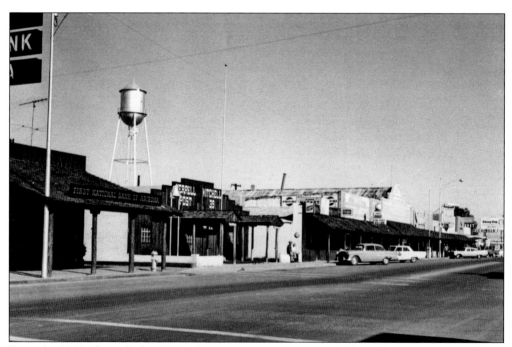

From the 1960s through the 1980s, the water tower was painted silver. The First National Bank building later became the courthouse and police department. The American Legion Post 39 building, constructed in 1950, is to the right. Above the Legion building, the water tower can be seen.

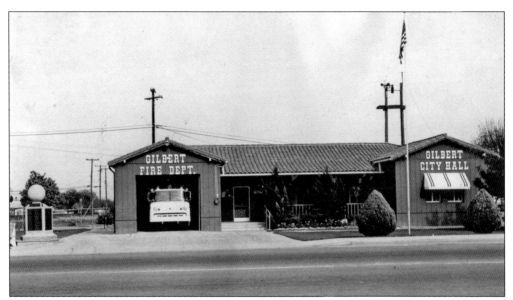

Gilbert's first town hall was dedicated on December 28, 1938. It was remodeled in the Western style in 1965. As seen here, the fire department is on the left, the clerk and manager's offices on the right, and meeting space for the council and town events in the middle of the building. The jail was in back of the fire engine garage.

Gilbert's first library was in the basement of the town hall building. In 1958, a group of women began raising money to build a new library, which was opened in 1963 on the southwest corner of Oak Street and Bruce Avenue. Helen Nunn started out as a "basement volunteer" and was instrumental in the formation of the library. She served as the library director for 27 years, retiring in 1988. In 1953, the monthly book circulation was 900 and grew to over 11,000 by 1988.

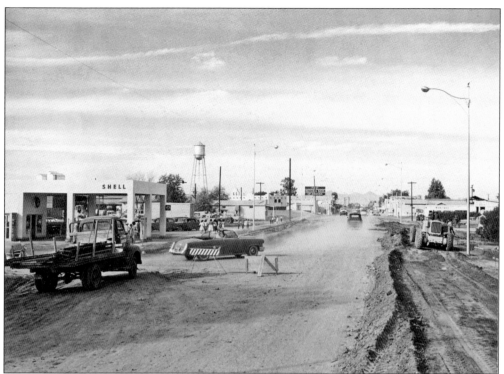

The April 1956 photograph above shows Main Street (Gilbert Road) right before street improvements were made and the road was paved. Below is a view looking to the west from the corner of Main Street and Elliot Road. A new sewer system for the town was installed in 1949. These improvements were controversial at the time but shepherded through by then mayor Kenyon Udall and soon-to-be mayor Morris Cooper.

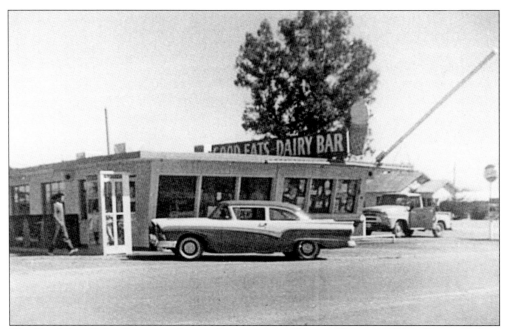

The Good Eats Dairy Bar was at the northeast corner of Hearne Street and Main Street (Gilbert Road) and a very popular eatery for several years in the 1960s. Hearne Street was named after Richard Hearne, one of Gilbert's mayors. Jake and Evelyn McCullough owned and operated the business but then sold it to Jim Gorgusis, who called it Jim's Dairy Bar.

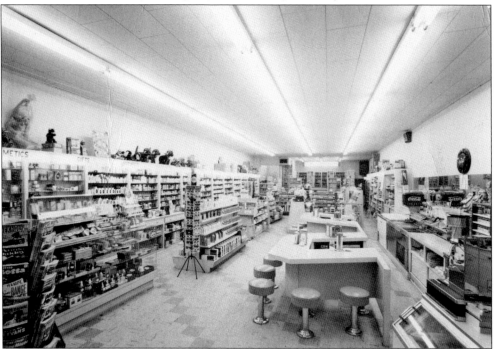

Tom Cady moved to Gilbert from Gallup, New Mexico, bought the Gilbert Pharmacy (shown here in 1958), and worked as a pharmacist for many years. Cady was a leader in the community and a strong supporter of Gilbert Public Schools.

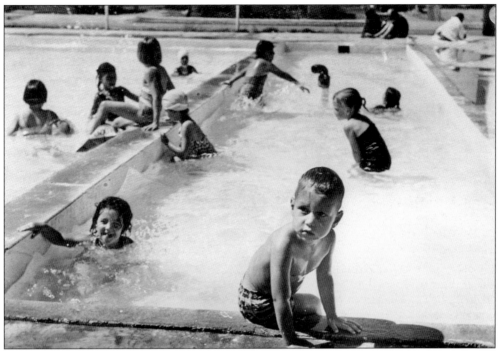

The Gilbert swimming pool project was started by the Gilbert Woman's Club in the 1920s and finished by the Gilbert Jaycees in the 1940s, with the help of the entire community. The pool opened in 1947 and was located on the northwest corner of Oak Street and Park Avenue. Today, the Town of Gilbert partners with area school districts to operate four public pools—the Mesquite Aquatic Center, Greenfield Pool, Perry Pool, and Williams Field Pool.

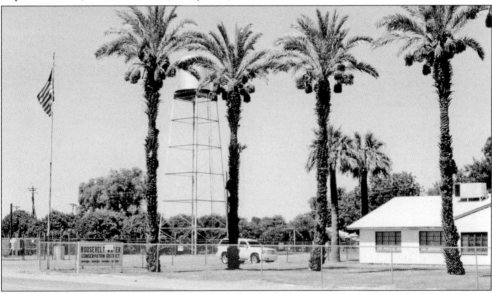

The Roosevelt Water Conservation District (RWCD) is a municipal corporation and an irrigation district formed in 1920. Its offices are on the northwest corner of Higley and Williams Field Roads. The RWCD service area covers 40,000 acres in Gilbert, Chandler, and Mesa. In addition to providing irrigation water, RWCD has a domestic water service agreement with Gilbert and Chandler.

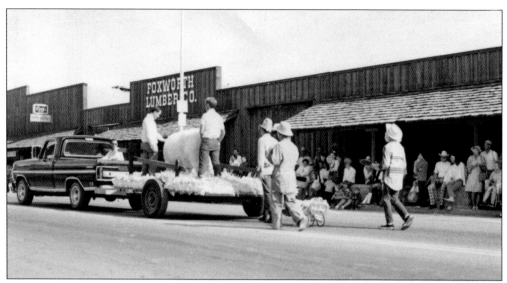

Gilbert Days was started in 1957 to celebrate the paving of Main Street (Gilbert Road). It was originally held in May as part of a Cinco de Mayo celebration in conjunction with an American Legion barbecue. It then moved to November for cooler weather and to be close to Thanksgiving for those coming in from out of town to visit family. In the above photograph, taken about 1965, Foxworth Lumber can be seen behind the float. This business was originally started by a Mr. Lynch in the 1920s and later sold to M.S. Vaughn, a former mayor of Gilbert. It later became Foxworth Lumber Company but burned to the ground in the 1970s. Dale Hallock, mayor from 1971 to 1976, is shown below with the 1975 Gilbert Days queens and princesses—from left to right, Cheryl Humphrey, Kim Van Camp, Hallock, Wendy Erring, Peta Mendoza, and Donna Sherwood.

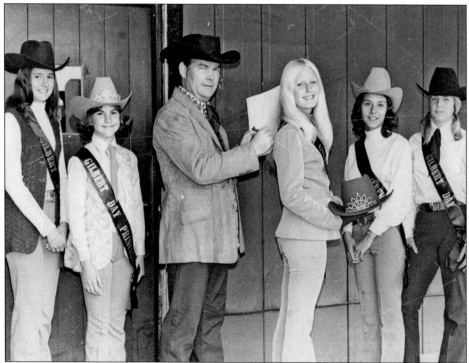

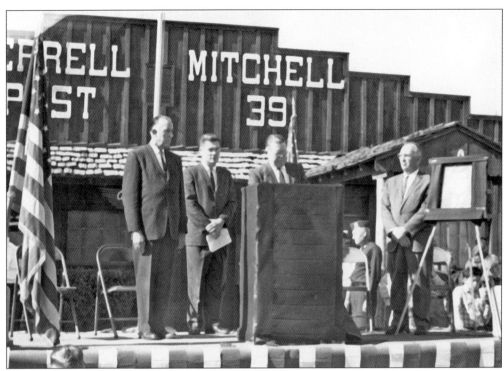

When Pres. John F. Kennedy was assassinated in November 1963, the annual Gilbert Days Parade was canceled. A stage was erected in front of the American Legion, and the town had a memorial service for President Kennedy. Gov. Paul Fannin was set to be the grand marshal of the parade that year, but instead he became the keynote speaker at the memorial service. Dale Hallock was the emcee, and Mayor Morris Cooper spoke at the service. From left to right are Fannin, Hallock, Cooper, and Reverend Wolfe.

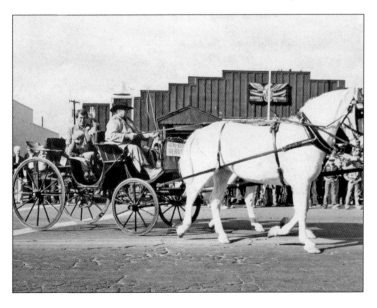

In 1980, Gov. Bruce Babbitt was the grand marshal of the Gilbert Days Parade. He is shown here passing in front of the Gilbert American Legion in a horse-drawn buggy. Prior to being the governor of Arizona, Babbitt was the Arizona attorney general and was instrumental in assisting Gilbert in expanding the local police department during the time Fred Dees was the chief of police.

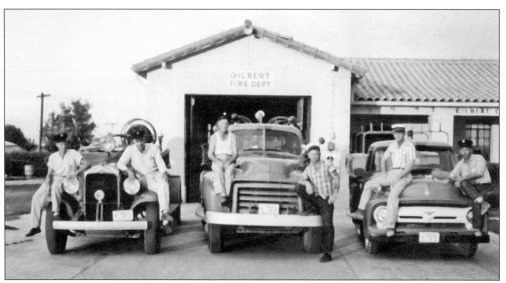

The first fire truck (above left) was purchased in 1929 for the volunteer fire department and is shown in this 1947 photograph. Volunteer firefighters shown are, from left to right, Lloyd Nash, Spinney Sotomayor, who later served as Gilbert's chief of police, J.S. "Red" Clay, Dick Thomas, Cecil Webster, and Cecil "Tince" Ross. Both Webster and Ross were volunteer fire chiefs.

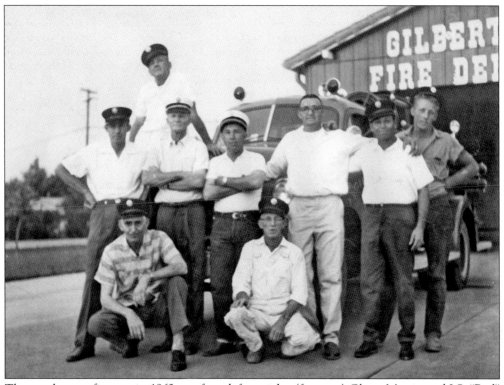

These volunteer firemen in 1962 are, from left to right, (first row) Glenn Martin and J.S. "Red" Clay; (second row) Jim Nunn, Chief Cecil Webster, Cecil "Tince" Ross, J.C. Hicks, Eddie Virzuela, and Jim Criss; and (third row) Charles Gillum. Volunteers not shown were Dick Thomas, Spinney Sotomayor, Stanton Van Pelt, and Vernon Gist.

In the 1950s and 1960s, Gilbert was a quiet and peaceful community that some compared to the fictional Mayberry, North Carolina, in the *The Andy Griffith Show*. The town employed two to three officers, and they were serious about their duties. In 1958, Andy Powell (right) was appointed town marshal. Cliff Beck (left) was one of the police officers. Powell and Beck were fondly known as "Andy" and "Barney" in reference to characters in the television show.

This map shows the strip annexation made in 1975 that encircled the 53 sections of land that gave Gilbert land for future development. The reason for the strip annexation was to prevent Mesa or Chandler from expanding into land Gilbert thought of as its own. The town later annexed additional land to give Gilbert a total of 72.6 square miles. The population has increased from 500 in 1920 to over 240,000 in 2015.

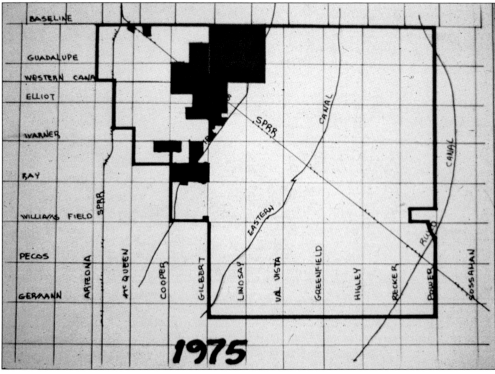

Geneva Sinclair married J.S. "Red" Clay in 1930, and they had one son, Sammy. Red was a volunteer fireman, farmer, and jockey for champion quarter horse Clabber. Geneva worked in the Gilbert Pharmacy and then co-owned the Gilbert Variety Store with her brother Eddie. Both Geneva and Red served on the town council. Geneva was chair of the Gilbert Days Parade from 1961 to 1973 and received the outstanding service award from the chamber of commerce in 1972.

John and Oris Gaines came to Gilbert in 1937. John worked as a foreman for Clyde Neely, started a custom hay-harvesting business with Clyde Peevyhouse, and eventually worked for Arizona Cottonseed Products until retiring in 1972. John and Oris were married for over 50 years. They are shown here with their children. Pictured are, from left to right, (first row) Oris, John, Juanita, and Louise (Gaines) Gilchrist; (second row) Evelyn (Gaines) Reed, Marla (Gaines) Lawrence, and Marie (Gaines) Shred; (third row) Kenneth, Dwight, John III, Gary, and William.

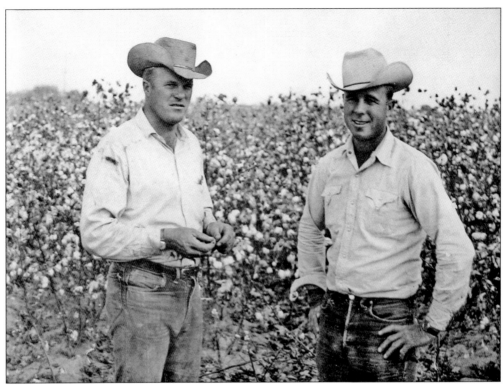

Marvin (left) and Kenneth Morrison returned from World War II and began a farming operation known as Morrison Brothers Ranch in 1946. This partnership lasted over 57 years. In this photograph, they are standing in front of a field of long-staple, or Egyptian, cotton, which grew well in Arizona because of flood irrigation. This tall cotton brought a higher price because of its longer fibers but tended to produce less per acre, so it eventually was replaced by short-staple cotton. The 1958 photograph below shows the home of Leatha and Howard Morrison, parents of Marvin and Kenneth, which was located at the northwest corner of Higley and Elliot Roads. Today, it serves as the offices of Morrison Ranch, created in 1998 as the development arm of the extended Morrison family. (Both, courtesy of the Morrison family.)

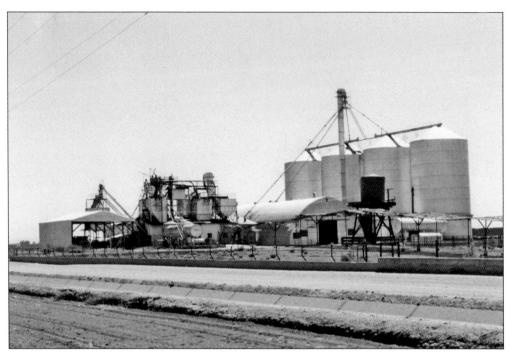

The Morrison grain tanks built in 1962 are a Gilbert landmark. Standing at 80 feet tall, they were the tallest structures in Gilbert for 45 years other than the water tower, and were used to store cattle feed. The structure in the far left of the photograph was a mill that took the various feed components, mixed them together, and then dumped them into a feed truck to be delivered to the steers in the feedlot. (Courtesy of the Morrison family.)

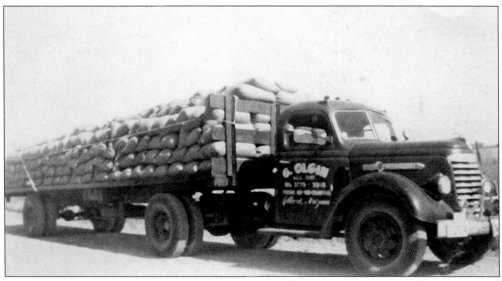

Juan and Ramona Olgin moved to Sonoratown in Gilbert in 1920. Juan and his son Gilberto hauled hay for area farmers during World War II. Gilberto married Tomasa Marquez in 1940 and worked in the trucking business until his death in 1966. They hauled wool, cotton, barley, wheat, watermelons, and other crops grown in the area.

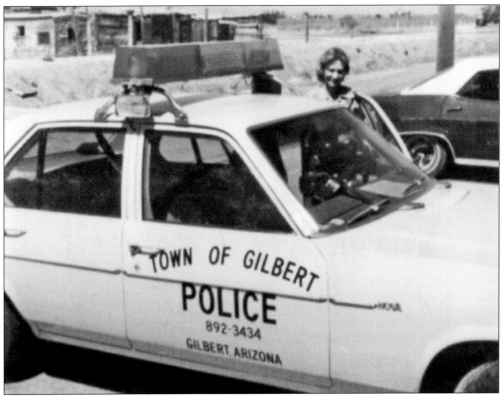

The Town of Gilbert initially advertised for males only in its police reserve program, but women soon began to make an appearance in the department. The first woman to become a sworn officer for Gilbert was Diane Ellis Blount, in 1974. She was originally the department secretary and court clerk but soon graduated from the Maricopa County Sheriff's Reserve Academy. She later resigned to pursue a career in nursing.

In August 1978, Espiridion "Spinney" Sotomayor resigned from the police department after 15 years. Longtime residents referred to him as Gilbert's Marshal Dillon. Following Sotomayor's resignation, Fred Dees (pictured), who was hired in 1974, became the town marshal. The official position of chief of police was not formalized until June 1976. Dees served until 1998. During his tenure, the department increased in size from six to 146.

Eight

MUNICIPAL GROWTH AND PUBLIC SAFETY

After the strip annexation in 1975, the population in Gilbert exploded. This was largely due to the extension of the Superstition Freeway, as it connected Gilbert to Phoenix so people could commute more easily. By 1985, this freeway extended to Power Road. Over the next three decades, Gilbert's population rose from 5,717 in 1980 to 109,697 in 2000 to 208,453 in 2010. Gilbert was the fastest-growing municipality in the United States from 1990 to 2003 and has remained in the top five since that time. The town had a massive job keeping up with the infrastructure to support this type of growth. There was even one point in 1996 where a year-long zoning moratorium was imposed so the town could get help from other entities to manage the growth. Gilbert had not been a full-service city prior to this growth, and unique funding strategies had to be developed and put in place to provide municipal services to the public.

In the early 1980s, Gilbert had one traffic signal at the corner of Gilbert and Elliot Roads. The water system consisted of wells and a few above-ground storage tanks, including the water tower. New wastewater treatment plants and utilities had to be constructed to accommodate the growth. There were no supermarkets or drugstores or national-brand retailers or fast-food chains. In the General Plan of 1986, town staff insisted that the SanTan Freeway be aligned to serve the new planned mall that was not actually built for another 20 years. Part of the negotiations on every zoning case included a mandatory discussion with school officials. Builders had to voluntarily contribute either land or cash payments to the school district so schools could keep pace with the growth.

In the early 1980s, Gilbert tried to turn the Arizona Public Service (APS) area (the original mile surrounding the Heritage District area) into a municipally owned power system. Lawsuits ensued, but eventually a settlement was made, and the area remained under the control of APS. There was much angst and division in the community, as residents and town leaders grappled with the best solutions to handle the overwhelming influx of people.

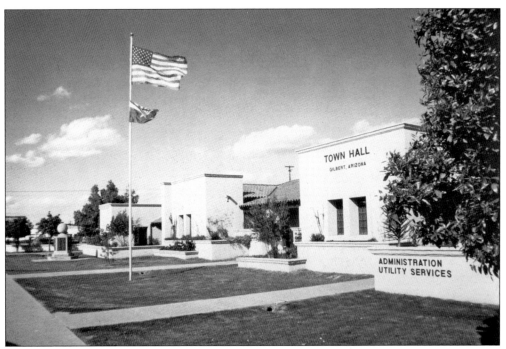

In 1982, town hall was remodeled and enlarged (above). Because of the enormous growth happening during the 1980s, different departments moved every few years to new locations on Gilbert Road. In 1989, a controversial election was held to determine where the new municipal complex would be built. The 20 acres of donated land on the southeast corner of Gilbert and Warner Roads (below) received over half the votes cast, beating out land that would have had to be purchased at Juniper and Gilbert Roads. The first new municipal building opened in 1992 and included the mayor's office, town manager's office, council chambers, and offices for other administrative staff. Phase one of the second municipal building just to the east of Muni I was completed in 2002 and includes development services and parks and recreation. A second phase of Muni II was completed in 2007. The public-works building near Freestone Park was erected in 1988, and the South Area Service Center at Greenfield and Queen Creek Roads was built in 2008.

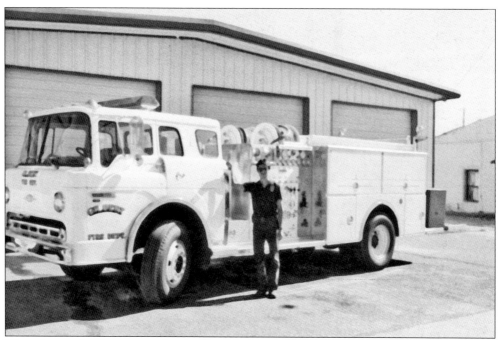

The volunteer fire department dissolved in 1982. Rural Metro Fire Department (RMFD) managed the reserve firefighters program from 1982 to 1985, at which time the town entered into a master contract with RMFD and hired two full-time firefighters. The first on-duty full-time firefighter was David Rodriguez, shown above with a new 1985 fire truck. The Gilbert Fire Department was formed after a vote by the citizens, and service began on January 1, 1993. Wes Kemp was Gilbert's first permanent full-time fire department employee. The photograph below shows the fire department's honor guard in front of the 1953 GMC fire truck owned by the Gilbert Historical Society but refurbished and housed by the fire department. Today, the department has grown to over 200 employees. There are 10 fire stations with nine engines, three ladder trucks, and seven other vehicles. In 2013, there were 15,719 incidents (calls, fires, and so forth). The average response time is three minutes 47 seconds.

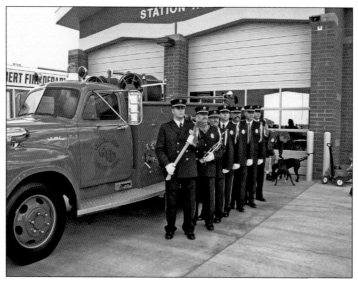

The Gilbert Public Safety Complex (pictured) houses police, fire, and the courts and opened in 2003. By 2014, the police department had grown to 228 officers, three canines, and 128 support staff, and there were 61,585 dispatched calls and 127,831 officer-initiated calls for service out of the main station and the San Tan substation. Gilbert has an active citizen volunteer program for both the police and fire departments.

Kent Cooper (left) served as Gilbert's town manager from 1983 to 2001, during a time of extreme growth when the number of town employees increased from 65 to over 700. George Pettit (right) served as the assistant town manager for 16 of those years and then went on to follow Cooper as town manager from 2001 to 2010.

Don Skousen served as Gilbert's town magistrate from 1974 to 1991. He was then appointed justice of the peace, serving for nine years, and then served two terms on the town council. Skousen's first elected position was in 1972, when he served five consecutive terms on the Gilbert Public School Board. David Phares followed Skousen as presiding judge of Gilbert from 1991 to 2008.

In 2014, Gilbert's municipal court handled misdemeanor criminal offenses, civil traffic offenses, and civil protection orders. There were 33 employees, including four judges. In 2014, there were 562 orders of protection filed, 20,281 filings for civil violations, 8,053 misdemeanor criminal violations, and 2,673 petitions to revoke probation or contempt complaints.

Freestone Park was the first of five major district parks in Gilbert. It opened to the public in June 1988 with 65 acres and has since grown to 88 developed and 32 undeveloped acres. Included in the park are softball fields, basketball and tennis courts, a skate park, a disc golf course, concessions, playgrounds, a carousel, and the miniature Freestone Railroad, which circles the lakes at the park. A 50,000-square-foot state-of-the-art facility, the Freestone Recreation Center (above) opened in December 2002. The McQueen District Park was approved by the voters in 1988 in a bond election. The McQueen Activity Center (below) opened in 1997, the ball fields opened in 1996, and the final phase, which added a gym, additional fields, trails, and a lake, opened in 2004. Plans are being developed to add another large park in the southeastern part of Gilbert.

The Riparian Preserve was developed by the Town of Gilbert in 1999 as part of its commitment to reuse 100 percent of its effluent water. Sitting on 110 acres, there are seven water-recharge basins that are filled on a rotating basis with treated effluent and allowed to percolate into the aquifer, where it is stored for future use. The preserve is organized into various vegetative zones ranging from marshlands to native riparian and upland vegetation areas. There is a paleontology dig site, an ethnobotanical garden, hummingbird and butterfly gardens, and the Gilbert Rotary Centennial Observatory. Many species of birds, fish, reptiles, and mammals live in this area. The preserve is part of Water Ranch, which includes the Southeast Regional Library, the Salt River Project Eastern Canal, the town's drinking water treatment plant, a fire station, and Nichols Park. The Riparian Preserve has many research, educational, and recreational opportunities for its visitors. The first riparian area in Gilbert was developed in 1987 as part of the Neely Wastewater Treatment Plant. Shown here is Scott Anderson, first director of the Riparian Institute.

In May 1991, Wilburn Brown was elected to council as a write-in candidate, which has never happened before or since. Prior to this time, the mayor was a council member elected by the people and then selected by the other council members to serve as mayor. Soon after that, the state legislature gave the option to cities and towns to have voters elect the mayor. So, in May 1992, Brown was on the town council and selected by his fellow council members to serve as mayor. In December 1992, Brown resigned from the council so that he could run for mayor. In March 1993, he was the first mayor elected by the people. Brown was chair of the Williams Gateway Airport Authority and responsible for negotiating an agreement that expanded the membership to include the Gila River Indian Community. He was succeeded by Mayor Cynthia Dunham, who was also chair of the Regional Public Transportation Authority and served on the executive board of the Maricopa Association of Governments. Their four-year terms allowed them sufficient time to work into regional leadership roles. Being elected by the public allowed a mayor a secure four-year term.

The Gilbert Community Center, home of the senior center, was built in 1982 and is located at the corner of Oak Street and Page Avenue. An addition was made in 1990, and a new building was constructed in 2007. A wide range of classes and activities are offered to the public, including a fitness center, computer room, and classrooms.

This photograph is of the 2000 ground-breaking ceremony for Heritage Court, at the northeast corner of Gilbert Road and Cullumber Avenue. Shown in this photograph are, from left to right, Tom Haug, Greg Tilque, Kathy Tilque, four unidentified individuals, Cynthia Dunham, John Eden, Steve Urie, Tom Billings (owner of Heritage Court), two unidentified people, Paul Heartquist, and two unidentified men.

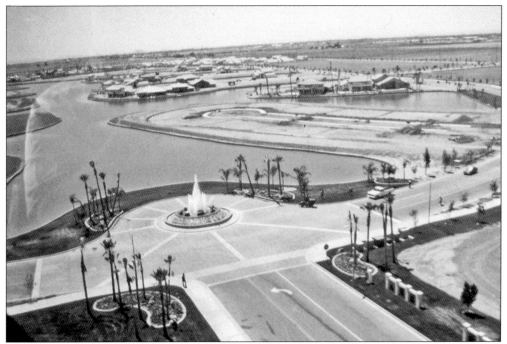

In 1984, development started on the Islands community. There were very few businesses or subdivisions in Gilbert at that time. The development grew to include 2,589 residential homes, one apartment complex, 27 commercial properties, 80 acres of lakes, and nine acres of grassy areas. In 1987, the Street of Dreams highlighted the Islands and brought regional attention to the area.

In 1985, Gerald Ricke, Dennis Barney, Ray Olson, and Tom and Don Stapley helped set the high standards Gilbert has for development by creating Val Vista Lakes, a master-planned community that has grown to over 900 acres with 24 residential subdivisions. Residents enjoy a clubhouse with parks, bike paths, lakes, and many water features.

Power Ranch (above) opened in 1999 and eventually included Trilogy, an active-adult neighborhood. This almost 2,100-acre master-planned community has over 7,000 homes. When it was on the drawing board, it became evident to the town that a new sewer plant in south Gilbert would be needed. At the time, only about half of Gilbert's planning area was in the town's corporate boundaries; the rest was under county jurisdiction. Some landowners in the county sought to create a sanitary sewer district to serve 15 square miles of unincorporated Gilbert. They would have circumvented the high standards of Gilbert and avoided impact fees. After months of negotiations, the attempt to create the special district was abandoned. When Seville (below) was developed in the SanTan General Plan area, it served as an anchor for extending utility lines. Seville supported a general plan amendment that preserved Gilbert's standards for development.

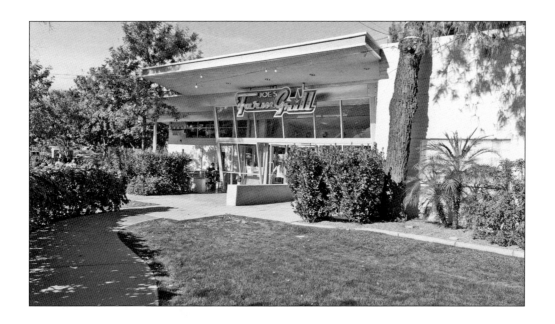

The Agritopia area on the northwest corner of Ray and Higley Roads was first homesteaded by the Reber family in 1927. Jim and Virginia Johnston purchased it in 1960 and raised their three sons on the farm. Their son Joe became an engineer and spearheaded the design to preserve urban agriculture in a walkable, friendly neighborhood. Construction began in 2000, and there are now 450 residential lots on 160 acres as well as Joe's Farm Grill (above), the Coffee Shop, a school, and a community garden. In August 2014, Generations (below) was opened with 122 units for independent living, assisted living, and memory care. This opening completes the development that fosters the concept of aging in place in Agritopia.

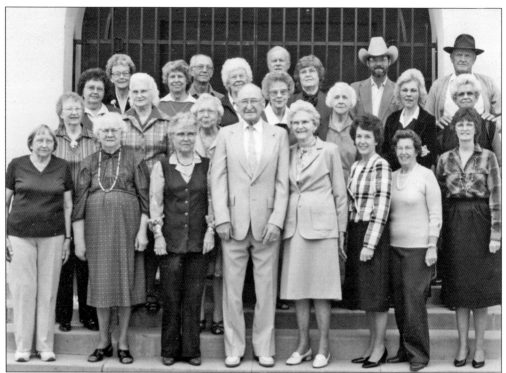

Members of the Gilbert Historical Society first started meeting in 1960 and collected artifacts in the hopes that one day they would have a museum and educational center. Their first choice for a site had been the train depot, but the Southern Pacific Railroad chose to tear it down in 1969 instead of allowing the town to use it for a museum. When the elementary school closed in 1977, the historical society knew this was the perfect location. In 1982, the society began leasing the building from the school district and opened the museum. The photograph above shows the members of the Gilbert Historical Society in 1985.

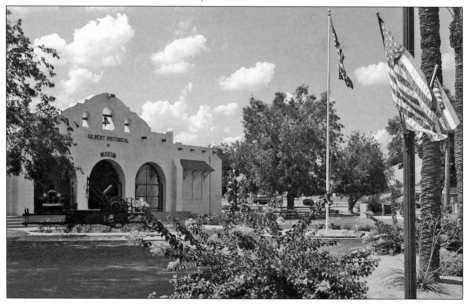

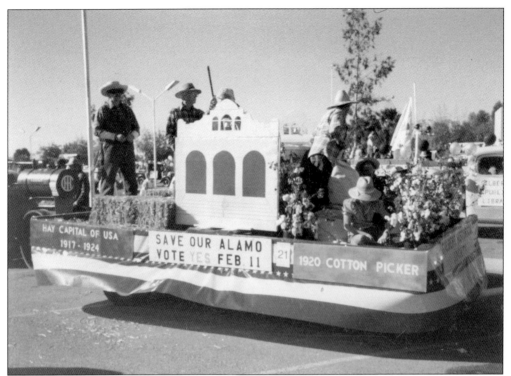

When the Gilbert Historical Museum opened in 1982, there was a state law that said school districts had to get approval from the voters to sell school land. The historical society started a campaign and even used its float in the Gilbert Days Parade (above) to encourage people to get out and vote. The voters unanimously approved the sale by a vote of 199-0. Otto and Edna Neely generously donated $300,000 to the historical society for the purchase of the land and building from the school district. The photograph below shows the Neelys with then society president Judy Lowry (left). In 1986, the building was placed in the National Register of Historic Places.

In 1996, the library was moved to the southeast corner of Gilbert and Guadalupe Roads (above). In 1999, the Southeast Regional Library (below) opened at the southeast corner of Greenfield and Guadalupe Roads. The Town of Gilbert and the Maricopa County Library District share in the costs of operations. The Perry Library, located at Perry High School, opened in 2007. The Town of Gilbert and the Chandler Unified School District have an intergovernmental agreement for operations of this library.

The Gilbert Chamber of Commerce was officially incorporated in 1978. Greg Tilque was the first full-time, paid executive director and then went on to serve the Town of Gilbert in economic and community development for 25 years. His wife, Kathy Langdon Tilque, has served as the chamber's president since 1996. Above is the ribbon-cutting ceremony for the opening of Rigid Industries in 2014. During the early 1990s, the town was experiencing rapid growth, which caused controversy between residents having difficulty dealing with the changes. A series of town hall meetings were held, and one of the top priorities that arose was the evident lack of future leaders who were educated about the community. In 1992, the chamber developed a Gilbert Leadership program to help residents learn about the inner workings of the community, with the goal of giving back in service. Below is a photograph of the historical mural project done by Leadership Class 21 on the side of the American Legion building. (Both, courtesy of Gilbert Chamber of Commerce.)

Nine

GROWTH AND THE FUTURE

After 2000, building permits slowed, but growth continued despite the recession. People continued to move to Gilbert, and new subdivisions continued to be built. The town expanded to 72.6 miles in its municipal boundaries, although there are still a few county islands within that area. Since 2006, four hospitals have opened. The southern loop of Arizona State Route 202, the SanTan Freeway, was opened in 2006. The first regional mall was built in 2007. Gilbert celebrated its 90th birthday in 2010, followed by the recognition of Arizona's centennial in 2012.

The Heritage District (the original downtown Gilbert) has seen revitalization comprised mostly of new restaurants but also a performing arts theater, a new plaza around the water tower, and a new park next to the Western Canal. In 2015, Gilbert will welcome another university to the area with the opening of St. Xavier University in this district. To accommodate the growth in this area, Gilbert opened a much-needed downtown parking garage in December 2014. Gilbert now has two sister cities—Newtownabbey, Northern Ireland, and Leshan, China. In 2014, Arizona's fourth temple of the Church of Jesus Christ of Latter-day Saints was opened in Gilbert. All of these firsts for Gilbert were celebrated with much fanfare as is typical in this community with a small-town feel.

The town has continued to expand its economic development initiatives and has seen success in areas such as technology, health care, and retail. In 2005, GoDaddy opened a call center in Gilbert. In 2010, Orbital Sciences took over a former General Dynamics facility on East Elliot Road. And in the last quarter of 2014, ground was broken on Rivulon, a 250-acre mixed-use development located at the corner of Gilbert Road and the SanTan Freeway. This complex will include approximately three million square feet of office space, 500,000 square feet of retail space, and hotels.

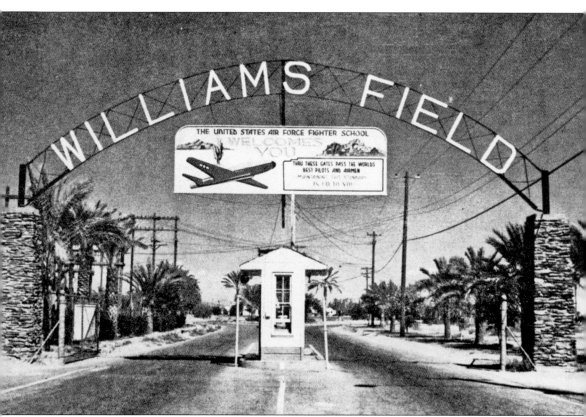

For over 50 years, the former Williams Air Force Base was a pilot-training facility graduating more student pilots and instructors than any other base in the country. Closed in 1993 and reopened in 1994 as Williams Gateway Airport, it was renamed the Phoenix-Mesa Gateway Airport in 2008. In 1984, after the City of Mesa decided to annex the base, Gilbert sued to invalidate Mesa's action. The two cities were able to work out an agreement whereby Mesa compensated Gilbert with a substantial settlement, and Gilbert dropped the lawsuit. This area has grown exponentially and now is home to not just the airport but over 40 businesses. Phoenix-Mesa Gateway Airport Authority owns and operates the airport. The authority consists of the City of Mesa, City of Phoenix, the Gila River Indian Community, Town of Gilbert, Town of Queen Creek, and City of Apache Junction. (Courtesy of the Chandler Museum.)

Created in 1998, Morrison Ranch is an example of how a Gilbert family transitioned from farming to development. The family has served as the major developer for their 2,000-acre, nationally recognized, master-planned community that requires tree-lined streets, open-space corridors, and homes with porches, creating a sense of neighborhood not widely captured by other developments.

In May 2012, the Morrison family announced that the last full square mile of Gilbert agricultural farmland was going to be developed as part of the Elliot Groves subdivision in Morrison Ranch. Here, June Morrison shares her memories with a group of people who came together to acknowledge the significance of this event. (Photograph by and courtesy of Gina DeGideo.)

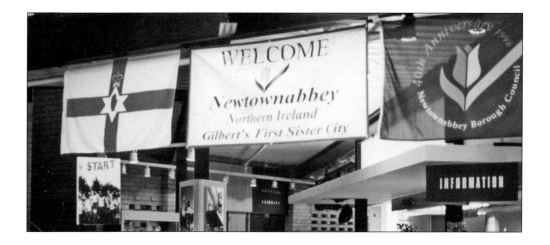

In June 1995, Gilbert's economic development director, Greg Tilque, formed a group of interested citizens to start a Gilbert Sister Cities program. Under the umbrella of the Gilbert Chamber of Commerce, the group was incorporated in January 1997. Newtownabbey, Northern Ireland, became Gilbert's first sister city in November 1998, and in the summer of 2000, a student-exchange program was initiated. In June 2002, Leshan, China, became Gilbert's second sister city. In April 2005, members of Gilbert Sister Cities started the annual Gilbert Global Village Festival. In the summer of 2010, a student-exchange program was started with Leshan. Several humanitarian programs developed through the Sister Cities program, and Mandarin Chinese is being taught in one of the Gilbert Public High Schools as a result of a visit to Leshan. Below, council member Larry Morrison accepts a gift from a Leshan representative. (Below, courtesy of Greg Tilque.)

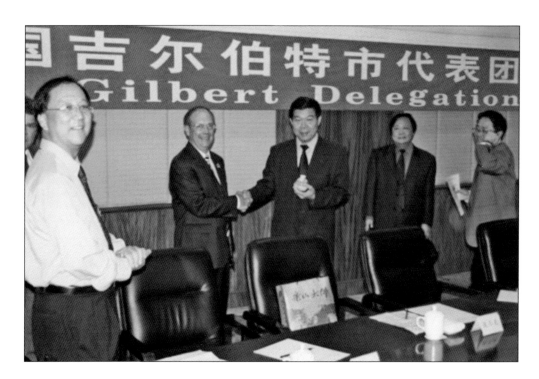

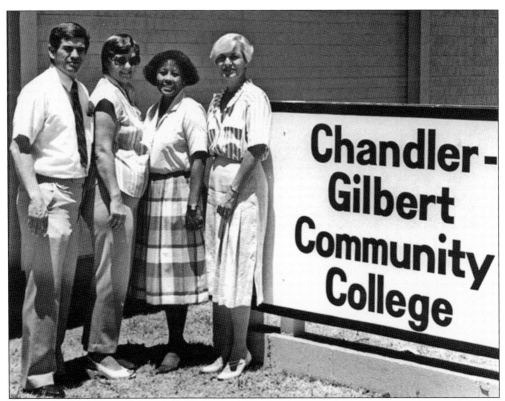

The Maricopa Community College District began planning for an expansion campus in the southeast part of the valley in 1979. Land was purchased in 1981, and the Chandler Education Center, housed at Seton High School in Chandler, opened in 1985 as an extension of Mesa Community College (MCC). Ground breaking at the Pecos and Gilbert Roads location was in 1986, and the first classes were held at the new Chandler-Gilbert Community College Center (CGCC) in August 1987. The word *center* was dropped from the name in 1992, when the college received its accreditation and could stand alone, apart from MCC. Arnette Ward was the first provost in 1985 and then the first president from 1992 to 2002. Ward was followed by Maria Hesse, who served as president from 2002 to 2009. Shown above are, from left to right, Andy Bernal, unidentified, Ward, and Margaret Haddad Hogan. The Williams campus extension was opened in 1996, and soon after the Sun City Center was built. The aerial photograph below was taken in 2001. The college currently serves over 19,000 students annually. (Both, courtesy of Chandler-Gilbert Community College.)

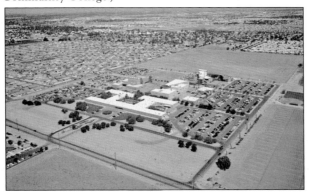

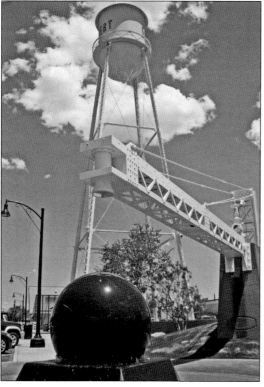

The half-acre plaza on Page Avenue west of Gilbert Road is the Gilbert Water Tower Plaza, which opened in November 2008. The water tower was used from 1927 to 1985 and has since been restored. The old adobe pump house beside it was Gilbert's first jail and has also been restored. Several features were added to the plaza, including a splash pad, a grassy open area for multiple uses, and a kugel ball. The ball is a 9.5-ton granite ball that, when given a push, allows a thin layer of water to move 19,000 pounds. Tami Ryall, who worked for the Town of Gilbert for 14 years, was very instrumental in the development of the plaza and other capital and preservation projects throughout the town.

In 2003, David and Corrin Dietlein opened the Hale Centre Theatre (above) across from the water tower on Page Avenue. This family-owned business has five theaters in three states and is the longest continuously running privately owned theater company in America. Co-owners Joe Johnston and Tad and Tim Peelen opened Joe's Real BBQ (below) in January 1998 in the Tone Building on the northeast corner of Page Avenue and Gilbert Road.

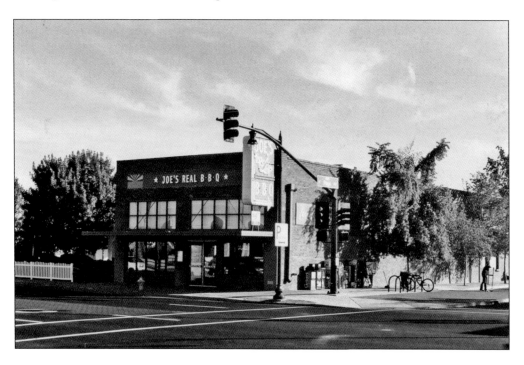

Heritage Marketplace is located on the northwest corner of Gilbert Road and Vaughn Avenue. It consists of 80,000 square feet of restaurant, retail, and office space. Directly behind the development is the Heritage District's first parking structure, opened in December 2014. This development further cements the district's reputation as a foodie destination.

Planning for the SanTan Freeway began in the mid-1980s, but the highway was not completed until 2006. This freeway is the southernmost portion of Arizona State Route 202. As Gilbert continues to grow to full build-out to the south, this stretch of roadway will become an even more important connection to the rest of the valley.

Opening in February 2006, Gilbert Hospital was the first emergency hospital in Gilbert. Located on Power Road just north of Pecos Road, Gilbert Hospital has seen over 300,000 patients in its first eight years, with an average wait time of 31 minutes or less. It now offers a complete array of traditional hospital services, including surgery, inpatient, and intensive care.

Opened on June 5, 2006, Mercy Gilbert Medical Center was Gilbert's first full-service acute-care hospital. It is part of Dignity Health, which was originally Catholic Healthcare West. From the opening day through November 2014, the hospital had 106,274 admissions, 363,015 emergency-room visits, 21,849 births (with 160 sets of twins), and 61,151 surgeries. Its sister hospitals include Arizona General Hospital, Chandler Regional Medical Center, St. Joseph's Hospital and Medical Center, and St. Joseph's Westgate Medical Center.

Banner Gateway Medical Center opened on September 18, 2007, at US 60 and Higley Road. Banner Gateway is a 177-bed community hospital offering emergency services, surgery, women's health care, obstetrics, and medical/surgical care. Banner Gateway is part of Banner Health, a nonprofit health-care system with 25 hospitals in seven states. (Courtesy of Banner Health.)

Banner MD Anderson Cancer Center opened on the Banner Gateway campus on September 26, 2011. Banner MD Anderson is a collaboration of Banner Health and the University of Texas MD Anderson Cancer Center. Banner MD Anderson offers specialized, state-of-the-art treatment for cancer patients in the East Valley, filling a much-needed niche.

The SanTan Village Marketplace is on the southwest corner of Williams Field Road and the Loop 202 freeway and has 285,000 square feet of retail and restaurant space. Planning began in 1988, and the center began opening in phases in 2005. Adjacent to it and north of Williams Field Road is SanTan Village Regional Shopping Center (shown here), which is a 928,000-square-foot retail center opened in 2007. (Courtesy of SanTan Village.)

Gilbert's celebration of Arizona's centennial was recognized with three events. In November 2011, Gilbert's first History Awards were presented to 13 individuals. That same month, the Union Pacific Railroad brought its historic steam locomotive to Gilbert. As seen here, over 5,000 people joined "conductor" Mayor John Lewis to celebrate what the railroad means to Gilbert's history. In February 2012, Gilbert Fest, a community art and music festival, was held at the Higley Center for the Performing Arts.

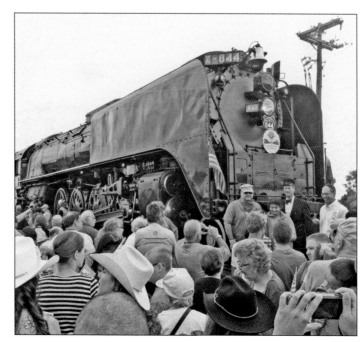

There have been 21 superintendents of Gilbert Public Schools, including two interims. J. Irwin Burk was the first superintendent, from 1914 to 1916. Jasper Cowart served from 1962 to 1981 and saw the beginning of the growth. But it was Dr. Walter J. Delecki (pictured), who came to the Gilbert School District in 1978 and served as the superintendent of schools from 1981 to 2001, who led the district through the phenomenal growth years. During his tenure, 26,000 students were added to the district and 29 new schools were built. The number of employees in the district increased from approximately 300 to 3,000. During the high-growth years, Delecki hired up to 300 teachers a year, but he never had to institute a split or double session in the schools. In 1996, Delecki was named the Arizona Superintendent of the Year.

Cosmo Dog Park was opened in 2006 and celebrates the unique bond between dogs and humans. The park is named after the Gilbert Police Department's first and most famous police dog, Cosmo, a German shepherd who joined the K-9 force in July 1993.

The Gilbert Temple of the Church of Jesus Christ of Latter-day Saints was opened in January 2014. Located at Greenfield and Pecos Roads, it is one of five LDS temples in Arizona. This photograph of the temple was taken from Discovery Park to the northwest. This park opened in 2006 and was named for the discovery of fossils of a Columbian mammoth near the site during construction. (Courtesy of the LDS Church.)

Discover Thousands of Local History Books Featuring Millions of Vintage Images

Arcadia Publishing, the leading local history publisher in the United States, is committed to making history accessible and meaningful through publishing books that celebrate and preserve the heritage of America's people and places.

Find more books like this at
www.arcadiapublishing.com

Search for your hometown history, your old stomping grounds, and even your favorite sports team.

Consistent with our mission to preserve history on a local level, this book was printed in South Carolina on American-made paper and manufactured entirely in the United States. Products carrying the accredited Forest Stewardship Council (FSC) label are printed on 100 percent FSC-certified paper.